Carving
Folk Figures
with Power

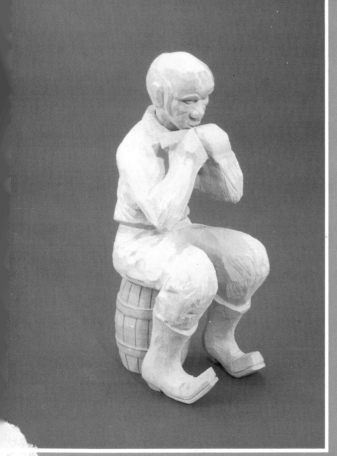

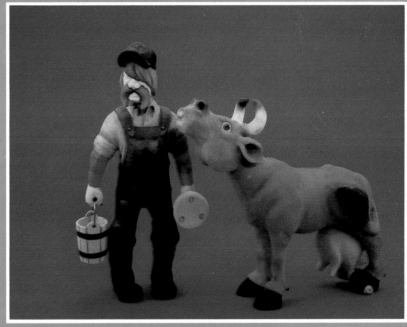

Frank C. Russell

77 Lower Valley Road, Atglen, PA 19310

DEDICATION

This book is dedicated to those special Vermonters who created and/or were a part of the stories and incidences that allowed me to create and continue to create caricaturizations such as are presented herein.

Library of Congress Cataloging-in-Publication Data

Russell, Frank C.
 Carving folk figures with power/Frank Russell.
 p. cm.
 ISBN 0-88740-854-0 (pbk.)
 1. Wood-carving. 2. Wood-carved figurines. 3. Folk art. I. Title.
TT199.7.R85 1995
731.4'62--dc20 95-11074
 CIP

ISBN: 0-88740-854-0

Book Design by (M J) Hannigan

Printed in Hong Kong

CONTENTS

Published by Schiffer Publishing Ltd.
77 Lower Valley Road
Atglen, PA 19310
Please write for a free catalog.
This book may be purchased from the publisher.
Please include $2.95 postage.
Try your bookstore first.

We are interested in hearing from authors
with book ideas on related topics.

FOREWORD

Incidences such as the milestone birthday are the stuff of folktale and legend; they are also fertile ground from which fine carvings spring forth. It is with that spirit that this book is presented. Once you have read this I hope you will be inspired to take incidences from your own lives for future works. Watch for them.

MILESTONE BIRTHDAY

It was my twelfth birthday, gateway to the teens, and soon I would be an adult, because *everyone* knew that teenagers were all grown up!

Next to the new bicycle that my parents gave me, the most treasured gift was the sling shot given to me by a fourteen year old cousin. The "Y" shaped handle had been carefully shaped from the crotch of an apple limb, with all lumps and bark removed. The sling pocket was made from a piece of real leather, and the slings were made from strips of the best used rubber inner tube that could be found. Later, such inner tubes would become a rarity due to the vulcanizing process.

Several friends and relatives attended the birthday party. My request for the type of birthday cake I wanted went far beyond expectations. My mother baked a huge single layer yellow sponge cake, put it in the bottom of a large metal tub, and poured quart after quart of real home-made whipped cream all over it before serving.

After the cake had been presented, sans candles, we youngsters were each given a large spoon, warned not to bodily enter the tub, and then allowed to eat as much as we wanted to. It was glorious!

After the cake, presents were given and opened, and indoor games were played until party's end. Not wanting the day to end, those that could stay on, continued to play outside.

My cousin showed me the intricacies of shooting the slingshot, and we had a wonderful time shooting at tin cans behind my house. Marbles, pebbles, ball bearings, or any handy missiles that would fit into the sling pocket were propelled at the cans.

Finally the sun began to set, and one of the larger cans was singled out for further abuse as goal for a game of kick the can.

"Kick the can" is a game much like hide and go seek, but instead of tagging a goal, a can is set on end as the goal (usually in the middle of the road or street), and kicked by the hider or tagged by the one who is IT. If the hider kicks before he or the can is tagged, hider and everyone else already caught is free to run hide again while the can is reset by the goal keeper.

Our game was well underway, and darkness had fallen to the point where only the brightest, whitest, objects could be seen. As I hid by the lilac bush near the corner of our house, I would load my slingshot with one of the few pebbles that I had left, and shoot at items that could still barely be seen, such as a street sign, a crosspiece on the garage door, or a garbage can.

Finally, I was down to my last pebble, and looked for a special target for my last shot of the day. About thirty feet away, I spotted a paper cup on the lawn, obviously discarded by someone who had brought his punch drink outside from my party. I knew that if I hit it, I would hear the sound, and the cup would move, showing me the accuracy of my shot in the near darkness. Carefully I pulled back, centered on the cup, and let fly.

Imagine the surprise when my younger brother exploded, screaming, from the lawn!

I got a spanking, lost my sling-shot forever, and learned that the "paper cup" had been a "Kilroy was here" patch ironed on the back pocket of my brother's jeans. I had nailed it (and him) dead center as he lay on his stomach, hiding in a depression on the lawn.

Though he feigned great injury, I know my butt was redder and hurt more than his did! So much for the gateway to adulthood.

INTRODUCTION
TOOLS AND MATERIALS

Purchase the very best tools and equipment that you can afford to carve with. I seldom find second or third best quality in a tool (or most anything) to be sufficient in the long run. It is less time consuming, more satisfying, and easier to create with a tool or medium that you trust and feel confidence in. If you don't have to worry about a tool staying sharp, or a power tool running intermittently, it's much easier to give your full attention to whatever you are creating. It's something like having to make a long road trip with the engine of your car acting up. Chances are, you won't be enjoying the scenery, or the company half as much as you would if you knew the engine was running properly.

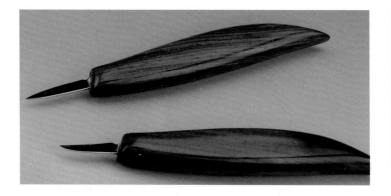

Carving knives

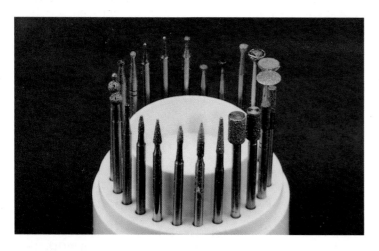

Diamond bits.

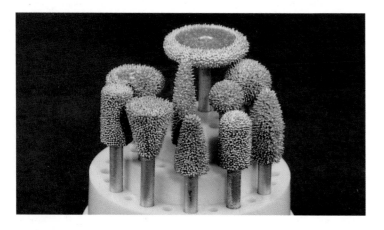

Carbide burrs.

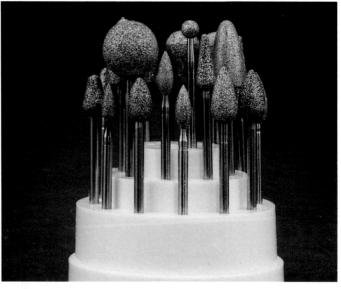

Ruby carvers.

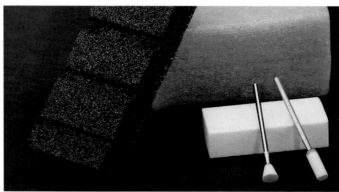

White stones. The two white stones are aluminum oxide bits. These are the two shapes used throughout this book for texturing hair and fur.
The black silicon carbide stone is used for shaping and sharpening aluminum oxide (stone) bits.
The white mineral block (used wet) is for cleaning diamond bits.
The large yellow neoprene (crepe) rubber block is used for cleaning stones and ruby bits.
Caution: ALWAYS CLEAN BITS AT A SLOW SPEED. Never clean carbide Kutzall's on a neoprene block. These bits are cleaned with a torch and brush or with oven cleaner and brush.

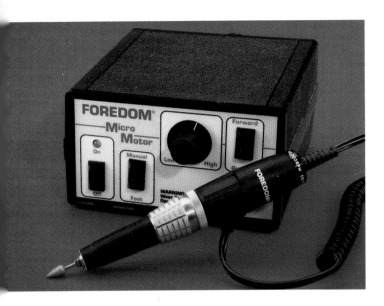

Micromotor, rated for 45,000 RPM.

Hand pieces for flexible shaft machine, rated for 19,000 RPM.

WORKPLACE

Give careful thought to your work place. Consider comfort and safety above all. Since I carve with power day in and day out, I am forever generating a fine dust with fine abrasive bits and frequent sanding operations. It doesn't take too many hours work without wearing a dust mask, and/or while forgetting to turn on my dust collection system, before I realize I'm beginning to wheeze and cough. Years ago, I subjected myself to prolonged periods of sanding dust and, as a result, it took a few years to get my dust laden lungs straightened out. Now I get a chest x-ray every year or so just to reassure myself that I am staying on the safe side and keeping myself dust free.

Proper lighting is another strong consideration for me. The older I get, the weaker my eyes seem to get and the more easily they tire. I've gone from wearing no glasses, to a single lens, to bifocals, and finally to trifocals over a period of twenty years, and now I find that sufficient, comfortable lighting is an absolute must. With it, if I choose to spend twelve hours daily in the studio, I'm not bothered with fluttering eyelids or headaches that I get from straining my eyes for a shorter period of time in a poorly lit working area. Adequate lighting is so important that I consider it to be one of the prime considerations and requirements for any facility where I am to present a seminar.

PAINTING HINTS AND SUGGESTIONS

Obtain the very best brushes you can afford. The quality of a brush plays a great role in the ease, feel, application, detail, and confidence that the artist/craftsman acquires through its use. There is no comparison between a top of the line sable round, and a synthetic or low grade sable round. The higher quality (or best) brush "points out" and holds its point better and longer for fine line and/or detail, while its barrel, or thicker part, holds a greater reservoir of paint in readiness for flow and application. Your confidence factor will grow to a higher level when a brush can be relied upon to follow your will or direction with ease; even the confidence of an experienced artist/craftsman rises with the brush quality.

Acrylic paints were used for all the projects in this book. Color washes (thin watery coats) were used in each area described and pictured to build color shade and intensity, and each wash was dried thoroughly with a hair dryer after it was applied. A small inexpensive hair dryer will soon become a necessity for the time it saves when used to dry acrylic color washes.

Colors are mixed on the palette with a palette knife. You will find the easiest way to separate, combine, and move colors about on the palette is with an easy to clean, flexible metal palette knife.

Lighting is the most important consideration for the painting situation. I prefer natural morning light, but best for all around work is a combination of incandescent and fluorescent lighting. Two clear glass, 100-watt incandescent bulbs combined with each single eight foot double fluorescent fixture, gives sufficient amount of light intensity, and "shade" of light preferred by the author. With this light combination, color shades check truest when compared in the natural daylight. Individuals preferences may vary, but no matter what light source or combination is used, insure that you have an adequate amount of light.

Maintain a correct, but comfortable posture in a chair that allows you to hold a position for extended periods of time without fatigue. It is difficult to concentrate when your neck, back, or legs ache from having been improperly held too long. If necessary, adjust the work surface or holding level up or down to allow your neck to remain in an unstrained position. If you find parts of your body cramping or aching after a short time, stand up, stretch, and analyze the situation to correct it before proceeding further with the painting process. Allow your body to dictate its own comfort level and position.

Allow ample time to apply color, blend, and detail to those areas or sections that you wish to complete. It is difficult to begin a blending process, then have to leave for a dinner party or to pick up the children, only to return and attempt to match the same blending process over or near a painted area already dried. Even worse is returning to a crusted or dried pallet that you forgot to cover. Conversely, nothing seems to lower standards more than rushing the painting process to get ready for *that* dinner party or to make *that* mad rush for the children.

When mixing a particular color, mix enough at one time to see you through to the end of the project. Running out of a mixed color when half finished is sometimes the cause for having to repaint a whole area because one can't mix back to the specific shade or tone that the area, or an adjoining area, was started with.

The steps presented for both the painting and carving segments are merely guidelines within which to work. As with any carving or painting project, allow your own creative talent to surface - don't be afraid to experiment. If an effort fails, you haven't lost, you've gained by learning not to do it that way on the project at hand; however, the technique and/or result of doing it in practice may serve you well for some other project.

PAINTING TERMINOLOGY

BASE COLOR - The predominant color of a section or area. A color that would suffice unto itself, even if there were no highlighting, shading, or detailing to give the illusion of depth.

BLEND - to combine colors taken from the palette and blended together in place on the carving - a technique used when highlighting and shading a base color.

HIGHLIGHT or HIGHLIGHTING - A spot or area accentuated by lighter paint to indicate either illumination or a place where the light hits an area that accentuates, and gives height.

SHADE or SHADING - A spot or area of reduced or deprived light - an area that accentuates, and gives depth.

MIX - Two or more colors that are combined on the palette to create a different hue or graduation of color.

REFLECTION - A point or spot of light put on an area that is supposed to be glossy or wet and therefore reflective of light, such as an eyeball or a light bulb. Reflection is used to enliven an area by indicating an exterior light source.

WASH - To flow a thinned, acrylic-based color over an area to create an effect. A wash can tone down a color area, brighten a color area, accentuate detail, or create a surface finish. With Acrylics, a wash is what it implies, a flow of water barely tinted with color. The best way to control a wash is to apply it in thin coats, dry it with a hair dryer, then reapply coats until the desired density or intensity of color is attained.

GLAZE - To flow a thinned, oil-based color over an area to create an effect. The same description applies as described for a wash, only using oil colors.

WET BLEND - The joining of two colors (usually extremes, like white and black) by bringing the two colors together to form a line, then drawing a cleaned, damp brush (such as a Filbert) directly over the line. The brush forms a blended transition zone between the colors that is more pleasing to the eye than the harsh, unblended, hard-edged meeting of the two colors.

PAINTING THE PROJECTS

COLOR SCHEDULES

The more I thought about including a color schedule for each of the projects in this book, the more I was compelled not to. I feel a choice of color for clothing and accessories should be left to the carver, since the carving is his or her creation. I will, however, include a few suggested mixes and techniques that I use which might be of assistance during the painting process.

A) I always make it a point to seal the project with a sealer that is compatible to the paint (acrylic or oil) that I am using. Sealing both protects the project from absorbing moisture and presents a more suitable surface to receive the paint.

B) Experiment with skin tone mixes and when you find a mix that serves as a "middle ground" mix, write down the exact proportions for future use. I prefer to mix my own skin tone colors from a combination of colors that allow me to darken, lighten, highlight, and shade by mixing up or down within the same color combination.

> **Base Color Mix For Skin** = Titanium White, Cadmium Red (Light), Cadmium Yellow (Medium)
> **(Caucasian)** = Base color, plus tiny amounts of Burnt Umber to add hue/tan, or Titanium White/Cadmium Yellow to lighten..
> **(African)** = Base color, plus Burnt Umber to color shade, then vary shade up or down with tiny amounts of Mars Black or Cadmium Yellow. **(Asian)** = Base color, plus Cadmium Orange (Medium) to color shade.
> **(Native American)** = Base color, plus Burnt Umber and Cadmium Red (medium) to color shade.

Take time to experiment, making notes as necessary, and practicing applications to get the effects that you want on a particular carving. Above all, insure that the skin tone is appropriate to the subject. You certainly don't need a deep weathered tan

on a carving of an infant or a female that the carving of a woodsman or sports figure would demand.

No matter what the carving, I always touch chins, cheeks, ear edges, and nose tips with Cadmium Red (Light) to accentuate the face - no matter how slight. Certainly delicate features of a Southern Belle will require much less reddening than a woodsman or a cowboy, who in turn require less than a drunken figure.

C) A good blue jean (Denim) mix for overalls, trousers, and work shirts is a mixture of Ultramarine Blue and Titanium White blended to the denim shade desired, then highlighted (as applied) with Titanium White and just a touch of Raw Umber, or shaded with Ultramarine Blue and a bit of Raw Umber.

Jeans look best when they have varying shades of blue whether for highlighting or shading creases and wrinkles or for showing faded areas on the knees, butt, pocket edges, or other areas of extreme exposure. Take the time to observe jeans being worn by people you meet and note just how many shades of blue there are and how they may or may not change with different angles of light.

D) With Acrylics, to better control color application, apply color coats thinly, drying between each coat with a hair dryer. This allows you to control the intensity of the color until you reach the shade and density desired. It also keeps the finish in a dull or matte state, which is more desirable on most carvings. Acrylics that are applied directly from the tube at full strength, will usually give a shiny or gloss finish, which in most cases is undesirable. Should this happen, two options are available - either tone that particular surface down with a few thinned coats of the same shade, or wait until the project is completely painted (prior to antiquing), and spray that area with a dulling medium such as Testor's Dull Coat or Krylon Matte Spray.

PART ONE: CARVING BASICS

CARVING FIGURES

The first two projects will introduce you to most of the carving techniques necessary to complete every project in this book. Techniques for carving details of anatomy and clothing are also provided.

CARVING THE GUARD CHICKEN

BIT SCHEDULE

The bits shown on the bit schedule were the exact bits used for this carving, but you should choose the shapes and/or sizes that feel best to you, and that give you the results you want. Whether manual or power tool, there are usually several ways to achieve the same result - don't be afraid to experiment on a scrap piece of stock. Note: when feather texturing, the higher the RPM, the sharper and cleaner the finish.

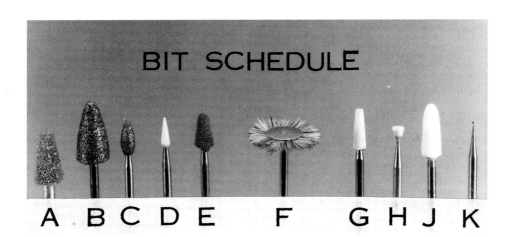

A	Tapered carbide burr	coarse	1/8" shank	
B	Round end taper ruby carver	medium	3/32" shank	
C	Flame shape ruby carver	medium	3/32" shank	
D	Elongated cone stone bit	medium/ coarse	3/32" shank	
E	Round end taper stone bit	coarse	3/32" shank	
F	Rotary bristle brush	soft	3/32" shank	
G	Square end taper stone bit	medium/ coarse	3/32" shank	
H	Inverted cone stone bit	medium/ fine	3/32" shank	
J	Round end cylinder stone bit	medium/fine	3/32" shank	
K	Inverted cone steel burr	fine cut	3/32" shank	

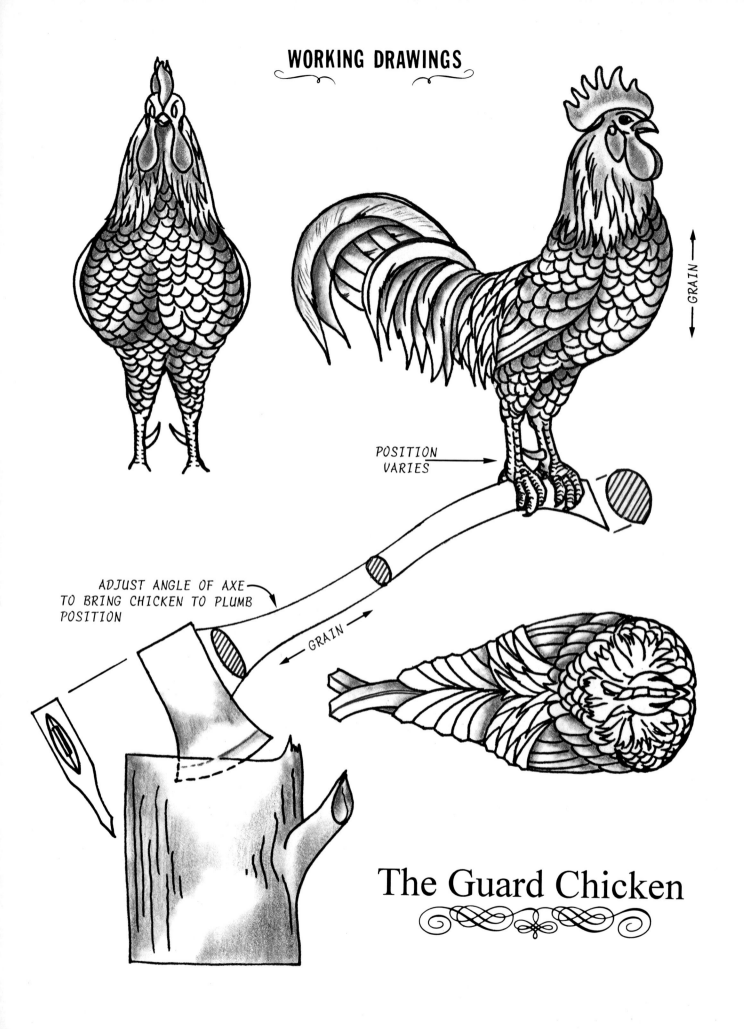

WORKING DRAWINGS

GRAIN

POSITION
VARIES

ADJUST ANGLE OF AXE
TO BRING CHICKEN TO PLUMB
POSITION

GRAIN

The Guard Chicken

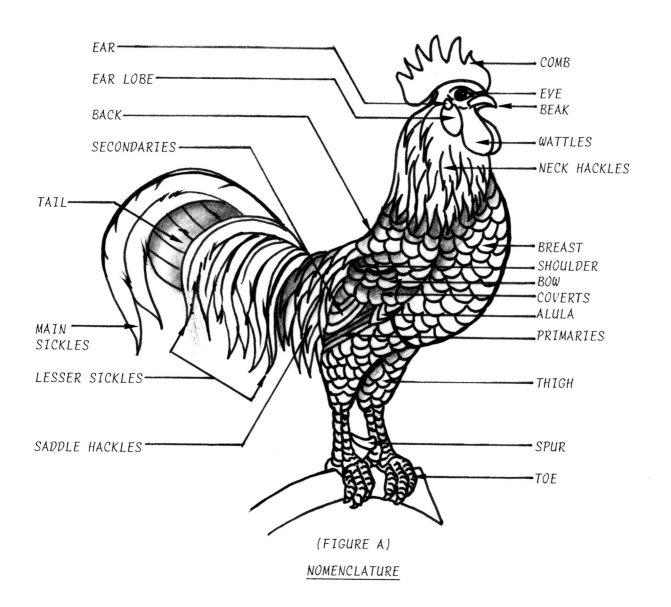

EAR

EAR LOBE

BACK

SECONDARIES

TAIL

MAIN SICKLES

LESSER SICKLES

SADDLE HACKLES

COMB

EYE

BEAK

WATTLES

NECK HACKLES

BREAST

SHOULDER

BOW

COVERTS

ALULA

PRIMARIES

THIGH

SPUR

TOE

(FIGURE A)

NOMENCLATURE

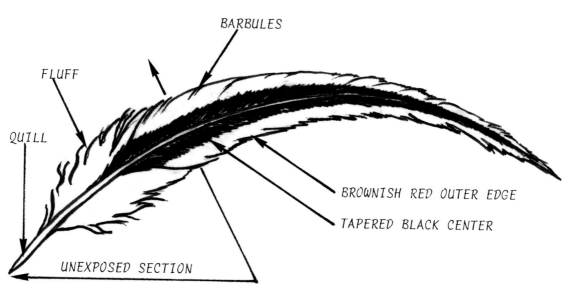

BARBULES

FLUFF

QUILL

BROWNISH RED OUTER EDGE

TAPERED BLACK CENTER

UNEXPOSED SECTION

(FIGURE B)

TYPICAL HACKLE FEATHER
(Brown Leghorn)

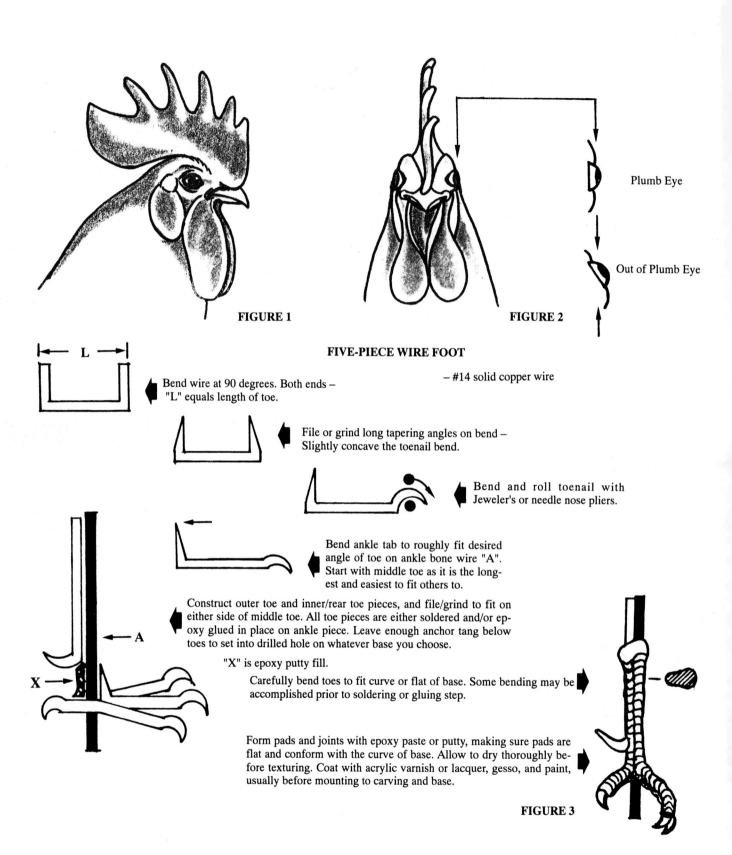

FIGURE 1

FIGURE 2

Plumb Eye

Out of Plumb Eye

FIVE-PIECE WIRE FOOT

– #14 solid copper wire

L

Bend wire at 90 degrees. Both ends –
"L" equals length of toe.

File or grind long tapering angles on bend –
Slightly concave the toenail bend.

Bend and roll toenail with
Jeweler's or needle nose pliers.

Bend ankle tab to roughly fit desired
angle of toe on ankle bone wire "A".
Start with middle toe as it is the long-
est and easiest to fit others to.

Construct outer toe and inner/rear toe pieces, and file/grind to fit on
either side of middle toe. All toe pieces are either soldered and/or ep-
oxy glued in place on ankle piece. Leave enough anchor tang below
toes to set into drilled hole on whatever base you choose.

A

X

"X" is epoxy putty fill.

Carefully bend toes to fit curve or flat of base. Some bending may be
accomplished prior to soldering or gluing step.

Form pads and joints with epoxy paste or putty, making sure pads are
flat and conform with the curve of base. Allow to dry thoroughly be-
fore texturing. Coat with acrylic varnish or lacquer, gesso, and paint,
usually before mounting to carving and base.

FIGURE 3

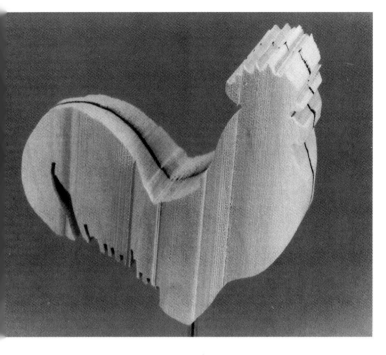

STEP ONE - Create the carving blank by cutting the top view, then the side view, away from the stock. Tupelo was the wood used for this project, but Bass or Jelutong are also suitable. Draw a centerline all the way around the blank. Use care, this line will be your guide to symmetry all through the carving - if you carve it away, re-establish it.

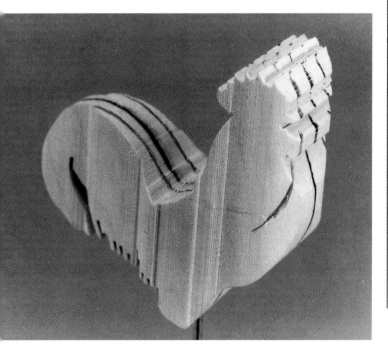

STEP TWO - Roughly outline areas where excess stock will be removed to begin the general shape of the project. Work from the centerline to maintain symmetry, keeping in your mind's eye those areas that may require extra stock. Leave extra stock where you envision a bulgy feather group, a turned head, a bent comb, or a highly exposed area that you want to highlight with additional detail.

STEP THREE - Begin rough shaping and rounding with a carbide bit similar to A on the bit chart. Take your time and begin to "feel" the shape of the project even at this early stage.

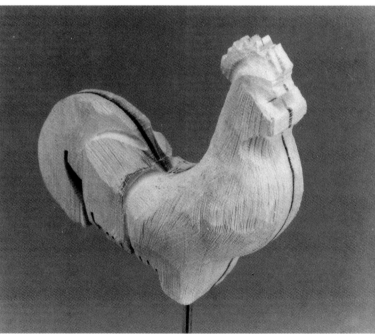

STEP FOUR - Keep both sides symmetrical as you carve. Refer often to the working drawings and any other reference materials. Allow your natural talent to start molding the desired shape(s) away from the blank. Finish roughing with a ruby bit similar to B for a smoother surface on which to draw. Continue to maintain the centerline.

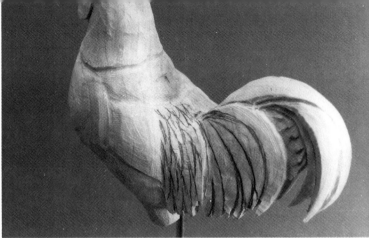

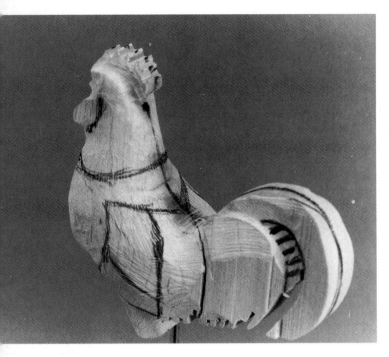

STEP FIVE - Draw the outline of general feather groups on the blank. Keep the groups evenly located and shaped from side-to-side. Be sure the size of the proposed feather groups are to scale with the size of the carving itself.

STEP SEVEN - Round and blend the edges of the feather groups, one into the other, into their general shape with a ruby bit similar to C. The feather groups may change slightly during the feather texturing step, but should give you some idea as to shape and grace at this time. Pencil in saddle, sickle, and tail feather details - if these feathers don't appear as you want them for the finished carving, erase and redraw them until they do.

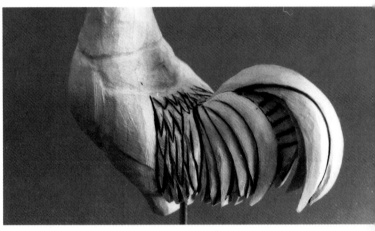

STEP EIGHT - Outline and undercut Step Seven feather groups with a woodburner. The shape of the woodburner tip depends on individual choice, but in general, use one that feels comfortable, allows you to make long curving strokes, and gives clean, sharp lines.

STEP NINE - Relieve feathers away from one another with a stone bit similar to D on the bit chart - some will curl over and across the tops of others, while some will serve as background feathers. Shape individual feathers with a stone bit similar to E.

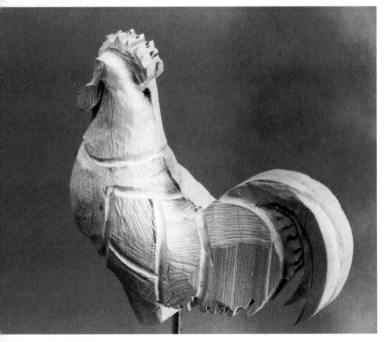

STEP SIX - Indent or relieve the feather groups away from the carving with a ruby bit similar to C on the bit chart. Hold the bit at a comfortable angle (20 to 45 degrees), and draw or "drag" the bit along the pencilled line toward you.

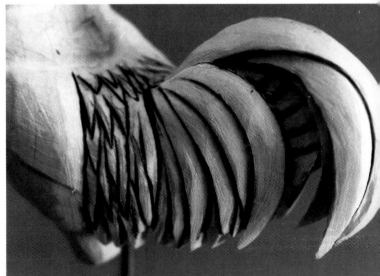

12

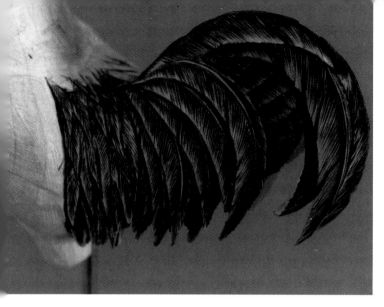

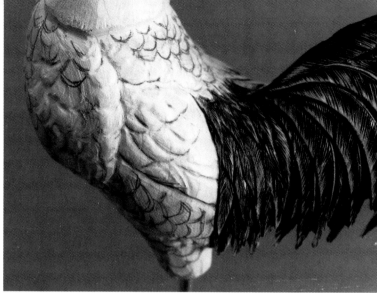

STEP TEN - Texture individual feathers by woodburning. Begin from the rear and work forward, texturing feathers that lie under or below other feathers first. Clean char residue with a bristle brush bit F, using a light touch that runs in the same direction as the burned strokes.

 Hints for beginning burners:

 Layout and burn a few feathers similar to those for the carving on a practice board first.

 Mark those that you like and use them as reference until you develop your skills.

 Experiment with different heat settings and strokes.

 Texture with parallel strokes that begin by touching the tip, and finish with a lifting curve that follows the direction of barbs away from the quill.

 If you don't feel any resistance, your tip is too hot, and control will be difficult.

 If you feel resistance with little color, your tip is too cold.

STEP TWELVE - Relieve indentations and blend the feathers into one another with a ruby bit similar to C on the bit chart.

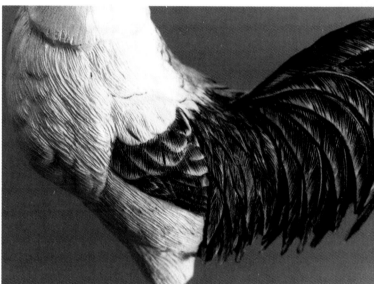

STEP THIRTEEN (a) - Feather texturing is done with a stone bit similar to G or H on the bit chart. The handpiece is held sideways at a 30-degree angle, with the leading edge of the bit making a small "V" groove to simulate the feather barbs. Controlled and measured strokes are applied, starting toward the rear and working forward. Some areas will be textured as an overall area, while individual feathers will be textured in other areas.

STEP THIRTEEN (b) - "Flow" lines drawn through an area to be textured will help keep the feathers pointing in the desired direction as texture is applied.

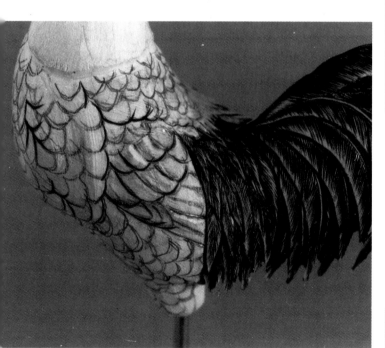

STEP ELEVEN - Draw individual feathers on body groups. Once you are satisfied with the layout, outline individual feathers within, and along the edges of different groups with a woodburner. Hold the tip in an almost vertical position and burn only as deep as you want the indentation between the feathers to go.

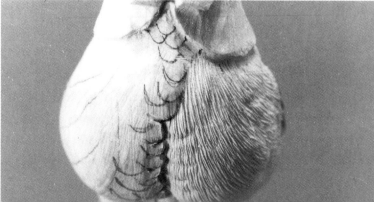

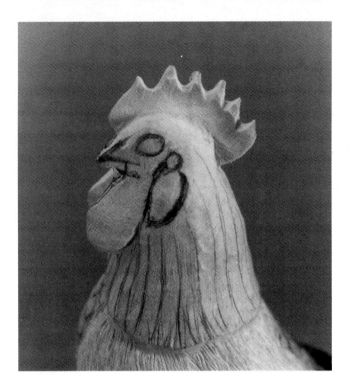

STEP FOURTEEN - Lay out general outline of the beak; refer to working drawings, sequence photos, and any reference photos you might have. Position the eyes - keep the eyes symmetrical from side to side, both on a horizontal and vertical axis. Nothing ruins a carving as quickly as to find the eyes out of plumb (see Figure 2), and/or out of position with one another. Outline wattles and ear lobes, maintain symmetry up and down, and from front to back on both sides.

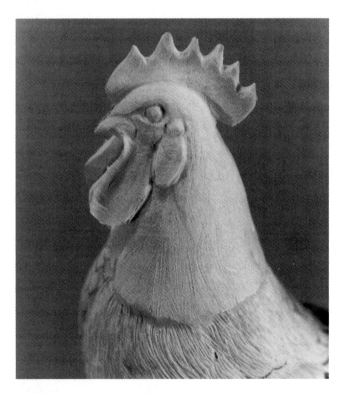

STEP FIFTEEN - Shape the beak and wattles with a ruby bit similar to C on the bit chart. Relieve and shape the eyes and ear lobes with the same bit, then smooth lobe and wattle hollows with the side of a stone bit similar to bit J on the bit chart (see Figure 1 for front and side head detail). Smooth the eyes, beak, and the area beneath the lobe and wattle edges with a stone bit similar to D on the bit chart. Re-shape the neck as necessary to blend with the head and into the shoulders.

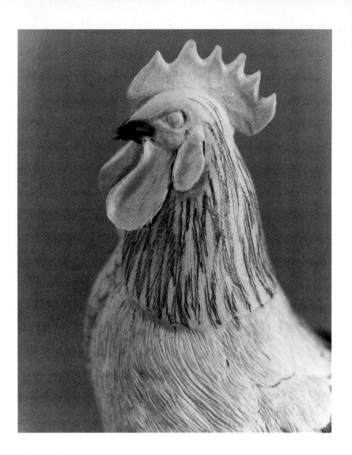

STEP SIXTEEN - Lay out the long, pointed feathers of the neck with a pencil using a random pattern - re-establish the feather "flow" lines on the neck (see Step fourteen) necessary before the feathers are drawn.

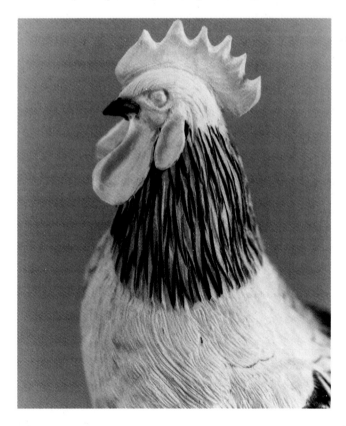

STEP SEVENTEEN - Burn feather edges, then relieve the edges and ends where the feathers overlap, starting at the bottom of the neck and working up with a stone bit similar to G on the bit chart. Remove just enough stock to give those feathers that lie over and above other feathers a raised look.

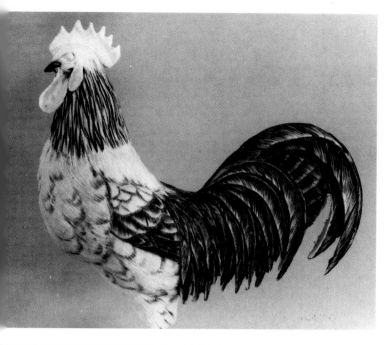

STEP EIGHTEEN - Touch up the entire carving by highlighting areas that you want to stand out or correct with a burning tool set at a temperature just hot enough to make an impression. Blend with existing texture - you want to highlight, not re-texture.

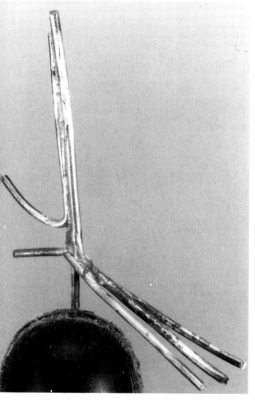

STEP NINETEEN - Feet were constructed of #14 solid copper wire. See Figure 3 for the wire pattern. Leave toes, spurs, and the anchor peg longer than necessary before soldering - silver solder was used for the project.

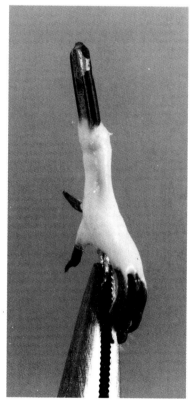

STEP TWENTY ONE - Cover areas lacking bulk for shaping and texturing with five minute epoxy paste or putty. Paste was used for this project.

STEP TWENTY - Cut spurs, toes, and the anchor peg to length, and shape toenails and spurs. Bend to shape around an axe handle or to whatever mount is chosen (an upside-down bucket also makes an excellent mount). Note the jeweler's vice used as a holding device while filing or grinding the foot into shape.

STEP TWENTY TWO - Shape the epoxied area with a ruby carver similar to C on the bit chart. (Epoxy will build up on a bit, so use an old bit at a slow speed, if possible) Detail the scaled effect on the toes and shank with a burr bit similar to K on the bit chart. Work carefully, and make sure that the foot is held securely in a holding device such as a jeweler's vice or similar hand vice through the entire shaping and texturing process.

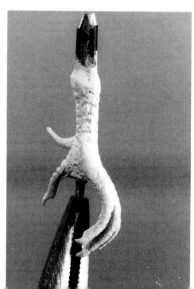

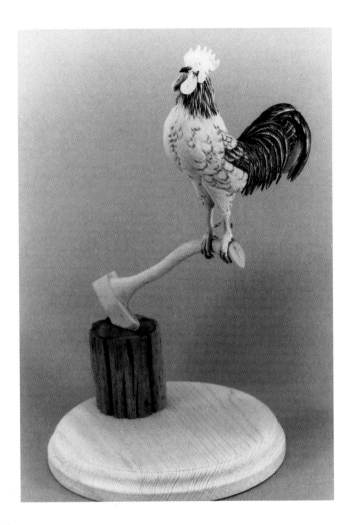

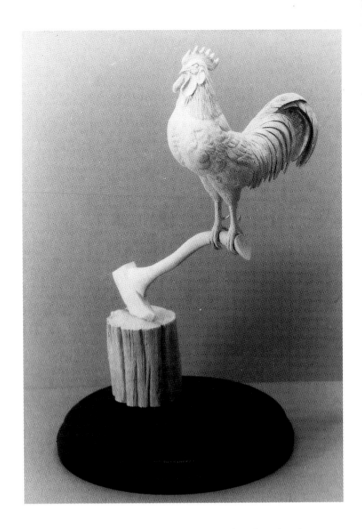

STEP TWENTY THREE - Seal all parts of the project with Acrylic Varnish or Lacquer, then loose-assemble the project for any final adjustments prior to painting.

STEP TWENTY FOUR - Once the project is adjusted and set to your satisfaction, apply several thinned coats of gesso with a stiff bristle brush to all the parts to be painted. The project is ready to paint.

PAINTING THE GUARD CHICKEN

COLOR SELECTION

Titanium White	Grumbacher Red
Mars Black	Cadmium Red Light
Raw Sienna	Cadmium Red Medium
Burnt Sienna	Cadmium Yellow Deep
Burnt Umber	Thalo Yellow Green
Raw Umber	Thalo Green
Yellow Ochre	Iridescent Gold

EQUIPMENT

Round Sable	Filbert Sable Brush
Bright Bristle Brush	Pallet
Pallet Knife	Hair Dryer
Water Containers (Two)	Holding device

NECESSITIES

Good lighting Comfortable chair Uninterrupted time

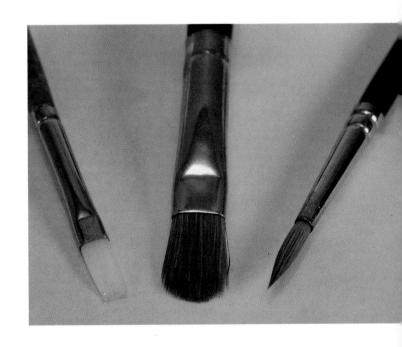

PAINTING SCHEDULE

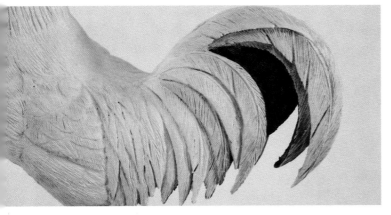

STEP ONE - Attach a holding device to the carving. Every effort should be made to keep your hands off a carving when painting. Movement of hands and oily moisture from human hands will eventually give the piece an unwanted shiny look, and/or worse, render the painting surface difficult to blend and apply Acrylic

washes to. A piece of coat hanger wire was bent, given outward spring, and inserted into the leg holes. This simple device held the carving nicely through both the painting and photographic processes. (When I paint any other carvings, I cradle the part being held in a soft dry cloth, or I wear a soft cloth glove)

STEP TWO - The entire piece is sealed with an Acrylic varnish or lacquer and dried. Then several thinned coats of Gesso are applied vigorously with a stiff bristle brush. Drive the gesso into the carving until it has the quality of a fine canvas ready to receive a fine painting. Dry thoroughly. See Figure A - Nomenclature, before beginning to paint.

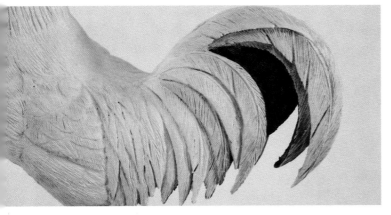

STEP THREE - TAIL - Base color of Mars Black with a touch of Burnt Umber. Feather edges highlighted by wet blending base color with a touch of Titanium white.

STEP FOUR - TAIL SICKLES - Base color of Mars Black with a touch of Burnt Umber, broadly highlighted with Thalo Green, in turn broadly highlighted with Thalo Yellow Green. Feather splits and some edges are highlighted by wet blending Thalo Green lightened with Titanium White. Wash selected areas with a wash of Iridescent Gold thinned to the point that the particles of iridescence seem to suspend in water. Before the gold wash can dry, wash over the entire area with clear water, leaving some areas highly accented with iridescence, other areas with very little, and still other "deeper" areas, with none.

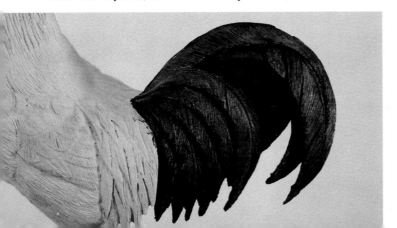

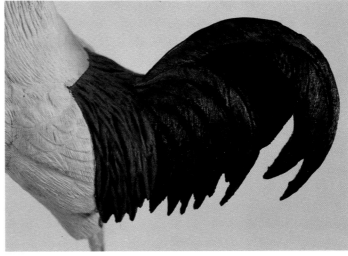

STEP FIVE - SADDLE HACKLES - Base color of Burnt Sienna and Cadmium Red Medium. On the pallet, add a touch of Raw Umber to some base color for shade, and a touch of Raw Sienna and Titanium White to

some base color for highlight. Use this same "three pile" method throughout the painting process wherever and whenever you plan to shade and highlight an area. The feather's center color is Mars Black "warmed" heavily with Burnt Umber.

Cover the entire saddle hackle area with washes of the base color. Bring the color to a point just short of the deep, rich final shade desired. As washes of the base color are applied, shade the edges by wet blending, and highlight the area center and some feather edges using the same method.

Give each feather (See Figure B - Typical Hackle Feather) a long tapering pointed center with the black feather center color, while dressing each feather edge with the base color at the same time, then dry blend by drawing a moist Filbert brush along the line where the two colors meet.

Highlight feather splits and edges with fine lines of the highlight color, and brighten the entire saddle hackle area with a very thin wash of the same color.

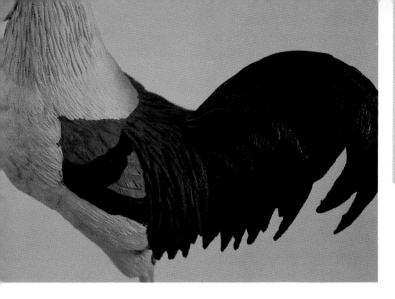

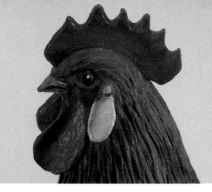

STEP SIX - WING (Secondaries or Wing Bay) - Base color of Titanium White and Burnt Umber mixed to a rich brown. Shade with Burnt Umber added to the base color, highlight with Titanium White added to the base color.

WING (Primaries & Alula) - Base color of Mars black and Burnt Umber mixed to a warm black. Highlight splits and edges by blending with a Burnt Umber/Titanium White mixture.

WING (Coverts) - Same colors and application as tail sickles. Be sparing with gold iridescence and allow the lustrous greenish black to dominate.

WING (Bow & Shoulder) - Base color of Burnt Sienna and Cadmium Red Medium. Shade with Raw Umber added to the base color, highlight with Raw Sienna and Titanium White added to the base color.

STEP EIGHT - COMB AND WATTLES - Base color of Grumbacher Red built in washes to a deep red. Blend cadmium red light at the edges for highlight, and blend Raw Umber in depressions for shade. The eye circle and cheek in front of the ear lobe are painted with the same base color. Give the wattles and comb two or three coats of thinned Matte Medium to give them a soft rubbery look.

BEAK - Base color of Raw Umber and Titanium White with a slight touch of Yellow Ochre mixed to a creamy horn color. Begin painting the beak at the base with dark (almost pure) Raw Umber and blend lighter and lighter to the point of the beak. Highlight the center ridge of the upper mandible (beak) with the base color lightened with Titanium White.

EARS AND EAR LOBES - Base color of Titanium White with a touch of Raw Umber to soften the bright white. Blend pure Titanium White at the top of the ear dome and ear lobe edges for highlight, and blend Raw Umber in the depressions for shade.

EYES - (Iris) Base color of Burnt Sienna and Cadmium Red Medium mixed to reddish-brown.

(Pupil) Mars black. Hint: a neat round pupil can be easily accomplished by square cutting the end of a toothpick to near size, then barely dipping the toothpick into thinned Mars Black and lightly touching the flattened end on the eye where the pupil is to be located. Make sure the pupil dots are of uniform size and symmetrically located from side to side.

(Eye highlight) Titanium White. Hint: the tiny dot of white serving as the eye highlight is made by sharpening the end of a toothpick, then barely dipping the pointed end into thinned Titanium White, and lightly touching the point just inside the upper rear edge of the pupil. Again, attain a uniform size and symmetrical location from side-to-side. Coat completed eyeball with a thick coat of Acrylic Gloss Varnish to give it a shiny, authentic appearance.

STEP NINE - BREAST, THIGH FEATHERS, AND UNDERTAIL - Same color combination as tail sickles. Cover each feather group separately with the black, then lighten the high spots on each feather group with Thalo Green and Thalo Yellow Green to make each section "stand away" from the depressions surrounding it. Be sparing with both greens and gold iridescence to give the breast and thighs a darker look. Wash the entire carving with a thin wash of Burnt Umber, then wipe the high spots with a clean, dry cloth (handkerchief material) wrapped tightly around the index finger. Residue of this wash will add depth and detail to feather texture and feather group depressions.

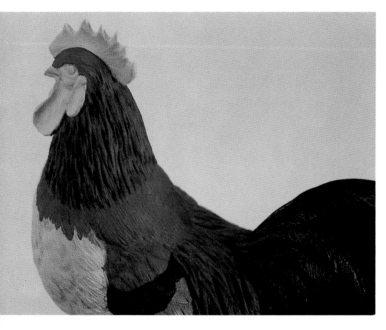

STEP SEVEN - BACK AND NECK HACKLES - Base color of Burnt Sienna and Cadmium Red Medium. Shade with Raw Umber added to the base color, highlight with Raw Sienna and Titanium White added to the base color. Lightly shade at the upper edge of the back, and lighten the middle back area with the highlight color. Apply the base color from the base of the beak over the top of the eye along the base of the comb downward to where the neck hackles meet the shoulder. Lighten the top sides of the head with the highlight color, and lightly shade under the lower edges of the wattles, ear lobes, and neck at the base of the beak in front. Add long black tapering points to the center of the neck hackles (See Figure B - Typical Hackle Feather) using the same technique used for the saddle hackles in Step Five.

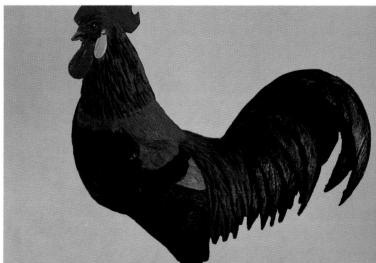

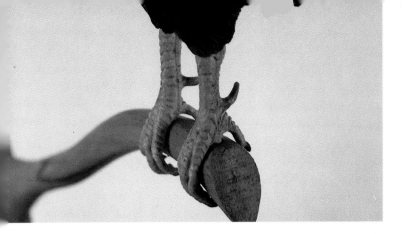

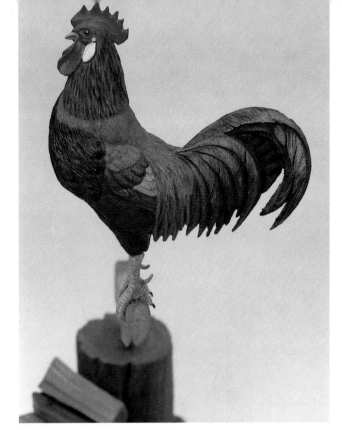

STEP TEN - LEGS, TOES, AND NAILS - Base color of Cadmium Yellow Deep. Blend Yellow Ochre along the back of the legs and on the sides of the toes for shade. Highlight the front of the legs with a touch of Titanium White added to the base color. Spurs and toenails are the same horn color as the beak. Wash the entire leg assembly with a medium/heavy coat of Burnt Umber and wipe with a dry cloth, leaving residue in the scaled texture depressions of the legs and toes. Apply one or two coats of thinned Matte Medium. Note: Do not paint mounting tangs beneath the feet or the upper ends of legs that will be epoxied into the body.

STEP ELEVEN - AXE (Head) Cadmium Red Light heavily applied to all but the sharpened edge which is Titanium White and Mars Black mixed to a silver grey (Option: Iridescent Silver)

 AXE (Handle) Yellow Ochre applied with long, streaky strokes along the entire length of the handle to give a wood grain appearance. Simulation of a crack in the handle is achieved with fine lines of Mars Black accented by fine lines of straight Burnt Sienna and a few fine lines of straight Yellow Ochre for highlight. Wash the entire axe with a heavy coat of Raw Umber for an antiquing effect.

 CHOPPING BLOCK - Base color of Burnt Sienna. Blend Yellow Ochre on all highlight areas, then wash with a heavy coat of Raw Umber. Lightly wipe Raw Umber away from high spots with a dry cloth, allowing the remainder to accentuate all the cracks, splits, knots, etc. that will give the chopping block a realistic appearance.

 BASE - Choose a base of a size that will give the mounted carving stability, but not overpower or detract from the detail of the carving. A five-inch round base was first chosen for the three-inch high chicken illustrated, but I decided that a freeform, grass textured base would accent the chopped wood, and give more to the overall carving.

The exposed earth was painted Burnt Sienna, with Yellow Ochre highlighting, and Raw Umber shading. The grass was painted Forest Green (not listed above) and dry brush highlighted with Thalo Yellow Green, stroking across the blades of grass.

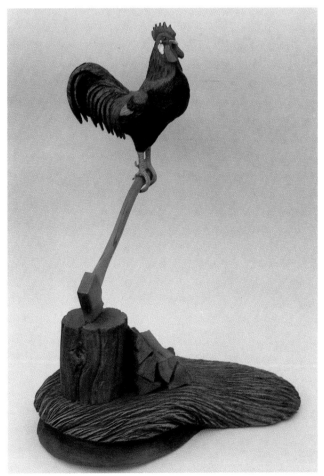

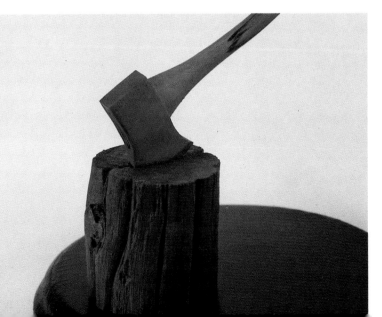

Author's note - The carving and painting may have been taken to greater detail than some carvers care to go, but hopefully, was presented in a manner that will permit choice for all. Different breeds of chickens will allow for different color choices and bird conformation by modifying the working sketch shown.

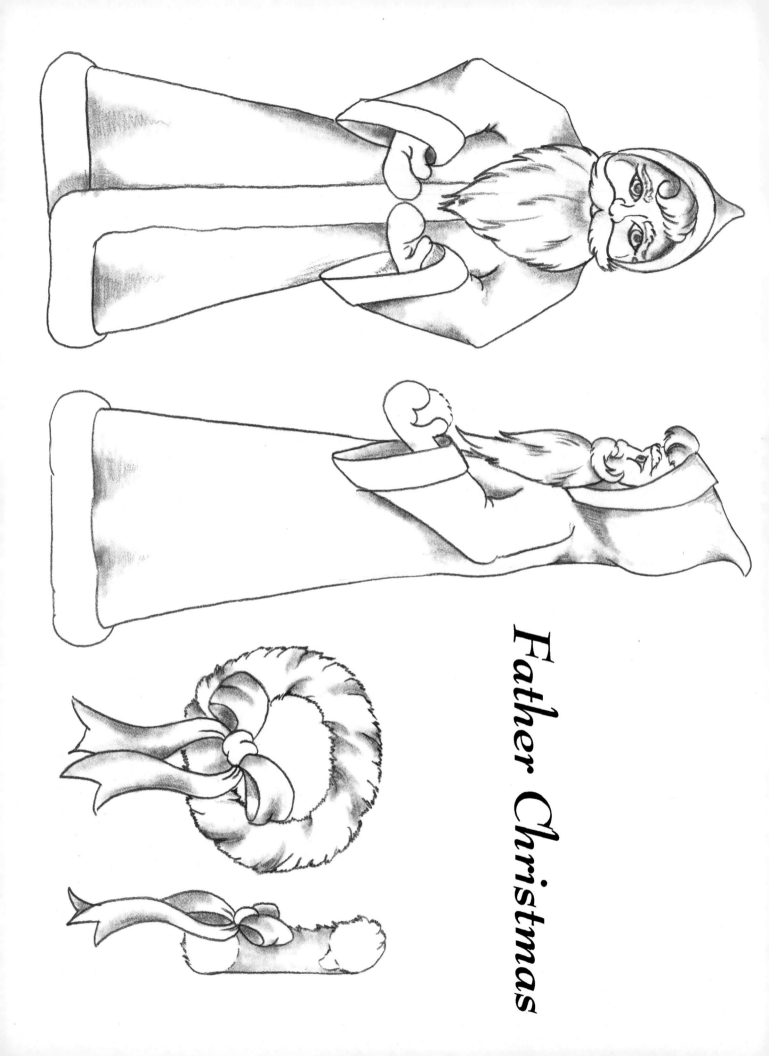

Father Christmas

CARVING FATHER CHRISTMAS

ROUGHING OUT THE CARVING BLANK

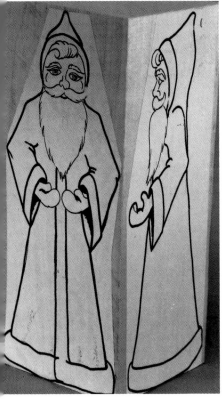

STEP THREE - Establish a Centerline (symbolized by a C with an L drawn through it) all the way around the front and back of the blank from top to bottom. Often it is helpful to do the same on the sides where symmetry is necessary, as on the lower part of the robe of this carving.

Locate and roughly draw in major details to be blocked out at this time - the beard, arms, and hands.

Estimate where stock will be removed to the blank corners and draw lines along the corners to represent the extremes to which stock will be removed from the corners.

As a reminder of areas where stock will be taken away (usually with hand tools), the area can be crosshatched with pencil as an alert symbol.

STEP ONE - If you don't wish to prepare a front and side view template before cutting the blank with a band saw, a quick way to prepare the blank for sawing is to glue the front and side views of the working drawing directly to the block. Make sure the views are squarely registered to one another from top to bottom.

STEP TWO - Cut the front view away in such a manner as to leave two complete side pieces. Cut the side view away in the same manner. Save the two pieces with the front and side view drawings glued to them, as they make excellent references that can be laid directly on the blank as measurements and details are transferred from them.

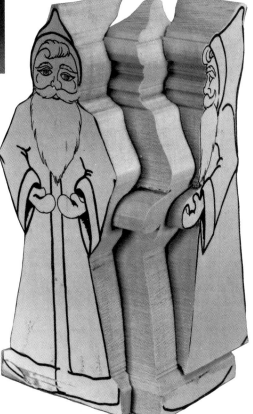

STEP FOUR - If you choose to "waste away" stock with a band saw as shown on Photo #4, set the table of your band saw at 45-degrees and cut away all unwanted stock that can be reached carefully and safely. Keep the blank flush with the table-top at all times and follow the lines you have drawn.

Carving the Body

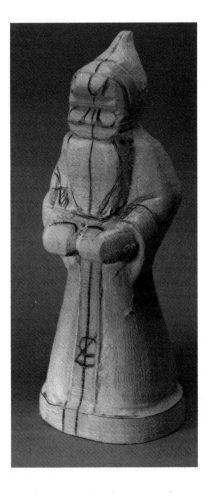

STEP FIVE - Block out the hair mass, head, beard, arms, and hands to the general shape desired.

- Rough shape and round out the entire robe including the arms and hands with a carbide burr.
- Give attention to everything but the face and beard at this time.
- Sketch and relieve, the furred trim along the bottom, down the front, around the sleeve cuffs, and around the hood.

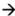

STEP SIX - Locate all areas where you want folds, wrinkles, and/or indentations with a pencil. You can easily ascertain with pencil whether or not a fold or wrinkle should go where you have drawn it.

- Relieve the large folds running down the lower robe with a carbide burr.
- Carve the creases or folds in the curled mittens, and the bent elbows of the robe with the flame shaped ruby carver.
- Remove stock from the inside of the sleeve cuff that hangs below the arm, and shape the inside of the cuff to the same shape that was given to the outside of the cuff with a flame shaped ruby carver. Steps Six through Ten will be carved with the flame shaped ruby carver.
- At this point, the entire carving (with the exception of the face) should be sanded lightly to remove tool marks - if tool marks are not desired as part of the finished carving.
- Touch up any areas that you feel need correcting or attention before carving the face.

Carving The Face and Beard

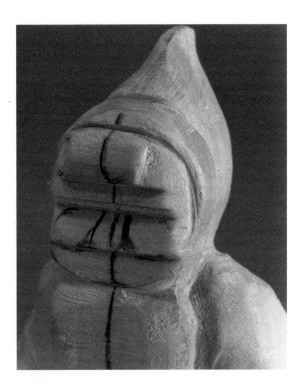

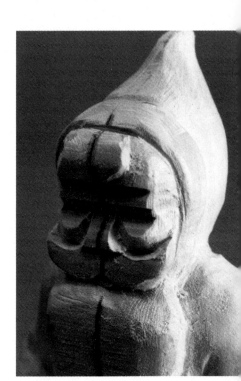

STEP SEVEN - Forming an imaginary equilateral triangle with the base along the facial plane at the eyes and the point meeting out in front of the nose, remove a small amount of stock from the sides of the forehead, temple, and upper cheek on both sides of the face above the mustache with a flame shaped ruby carver. Leave more stock for the cheeks if a chubby-cheeked face is desired.

- Working from the centerline and the sides of the face for symmetry, layout the mustache, nose, cheek, and lip shapes with pencil.

STEP EIGHT - Relieve the mustache, nose, lower cheeks, and a small mound outlining the area of the lips.

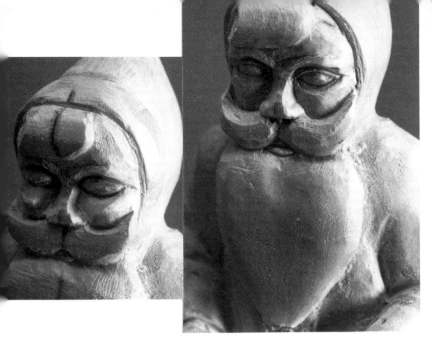

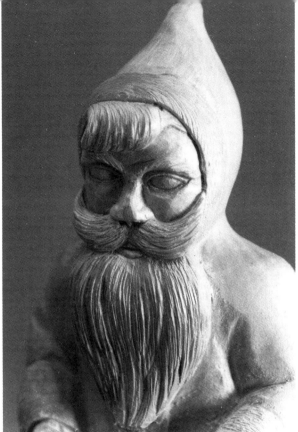

STEP NINE - Deepen the eye sockets on either side of the nose and continue that cut in a graceful curve that forms the underside of each brow. Make sure both sides are symmetrical from the centerline and along the eye line.
- Rough shape the nose.
- Layout and relieve the eye brows.

STEP TEN - Sketch and relieve eye lids. Round the mound of each eye and smooth out.
- Shape the upper cheeks to the eyes.
- Layout and relieve the nostrils.
- Shape the exposed portion of the lips.
- Carve and round out the beard to its final shape.
- Review and correct the entire face - look for any unsymmetrical areas from side-to-side. Smooth out the skin area of face (the smoother the better, as you will find when it comes time to paint the face).

STEP ELEVEN - With a sharp, soft-leaded pencil, sketch "flow" lines for the hair on the beard, mustache, and hair lock on the forehead. The lines drawn will represent the direction and manner in which the hair will lay, and should be followed as closely as possible during the carving process.

STEP TWELVE - Texture all areas of hair. Depth and coarseness of cut will determine whether a smooth, brushed out look is wanted, or whether a rougher, more "used" look is desired. All the texturing in this book is accomplished with the white stone bits that were previously shown (see bit shapes) in either the inverted cone or cylinder shapes.

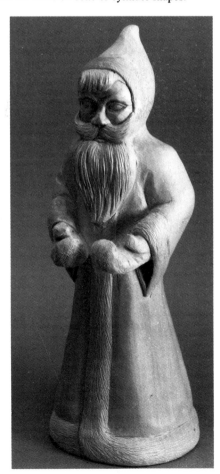

STEP THIRTEEN - Texture the fur liner along the bottom, the front, the hood, and the sleeve cuffs in the same manner, but with a finer, smoother cut than was used for the facial hair.
- Texture a knitted stitch on the exposed portion of the mittens.
- Once again, review the entire carving for any "fine tuning" on areas that you feel need correction.

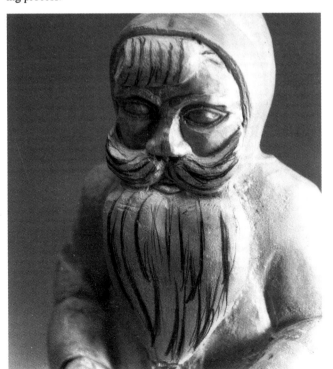

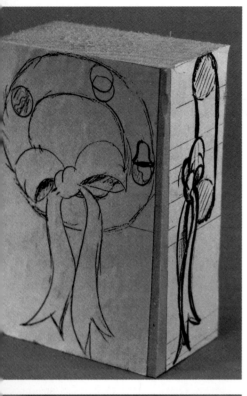

STEP FOURTEEN - Lay out with pencil, or glue the front and side views of the wreath and ribbon on a carving block in the same manner as in STEP ONE for the body.

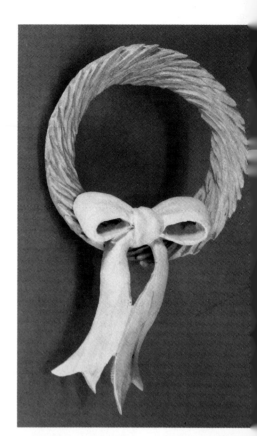

STEP FIFTEEN - Relieve the ribbon away from the wreath; cut out all areas where separation or depth are required. In this case, it may be easier to leave the paper drawing attached to give clues to the shape, depth, and areas of removal.

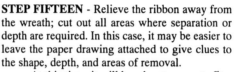

- At this time, it will be advantageous to fit the upper arc of the wreath to the mittened hands of the carving with respect to final position with the flame shaped ruby carver.

STEP SIXTEEN - Texture the wreath with long, coarse, interwoven strokes that represent evergreen twigs or spears with an inverted cone shaped white stone bit.

- Finish shaping the ribbon, then smooth it to a glossy finish - the smoother the ribbon is finished now, the more "satiny" it can be made to appear after painting. A piece of actual ribbon or scrap material tied to the general shape of the bow shown will be of great help if the carver has difficulty visualizing the shape of a finished bow knot. NOTE* - An alternative (and easier) method to achieve the ribboned wreath is to carve the ribbon bow separately and attach it as an applique to the wreath.

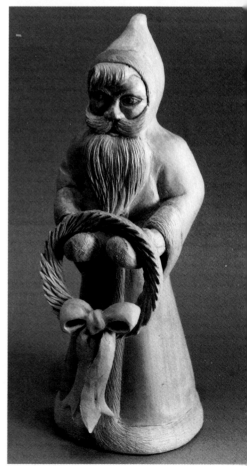

STEP SEVENTEEN - Place the wreath in its final position in the hands. Check the entire carving once again for position, balance, and stance, then correct any imperfections you feel necessary.

Do not glue wreath in place at this time. You will want to paint the wreath and/or ribbon separate from the body before final assembly and gluing.

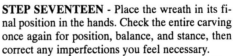

PAINTING SCHEDULE

Note* All the colors are Grumbacher or Jo Sonya Acrylics - any Jo Sonya colors used have a (JS) designation.

ROBE -
- Base Color = Napthol Crimson (JS)
- Shading = Burnt Umber
- Highlights = Cadmium Red (Medium)

ROBE TRIM (FUR) -
- Base Color = Titanium White with Raw Umber
- Shading = Base color with more Raw Umber
- Highlights = Pure Titanium white

MITTENS -
- Base Color = Cadmium Red (Medium)
- Shading = Burnt Umber
- Highlights = Cadmium Yellow (Light)

BEARD, MUSTACHE, HAIR -
- Base Color = Titanium White with Burnt Umber
- Shading = Mars Black with Burnt Umber
- Highlight = Titanium White (dry brushed across hair texture)

FACE -
- Base Color = Titanium White, Cadmium Yellow, Cadmium Red (Light) mixed to desired skin tone.
- Shading = Burnt umber
- Highlight = Cadmium red (Light)

EYES -
- Iris = Ultramarine blue with titanium white
- Pupil = Mars black
- Whites and Highlight dots = Titanium White

WREATH -
- Base Color = Pine Green (JS)
- Shade = Burnt Umber
- Highlight = Thalo Yellow-Green (dry brushed across sprig texture)

RIBBON -
- Base Color = Cadmium Red (Light)
- Shade = Burnt Umber
- Highlight = Cadmium Yellow (Medium)
- Finish = Matte Medium (after antiquing wash)

Author's Note* This carving of Father Christmas was presented in a relatively straightforward manner - holding a simple wreath with covered hands, with the face and wreath ribbon being the most difficult parts to carve. The first rendition of this carving had the entire head exposed with long flowing locks, the hood folded back with deep curving folds, and the subject holding a curved staff with bare hands. To date, several of my students have carved this piece, and the changes they have introduced on their own have been wonderful. One even carved the figure with an open and overflowing toy bag with each little, exposed toy carved to perfect scale. Others have not only changed arm positions and items held, but robe colors. Surprisingly, one done entirely in greens and whites was extremely attractive. One student even added little electric lights around the wreath, ran the feed wire down through the robe, out the bottom at the back, and uses the carving as the centerpiece on a beautiful antique hutch. I share this information with you who plan to carve this piece as a way of urging you to allow your own creative ability to direct you to further improve, change, and originate the unadorned beginnings found herein.

HANDS, FINGERS & FINGERNAILS

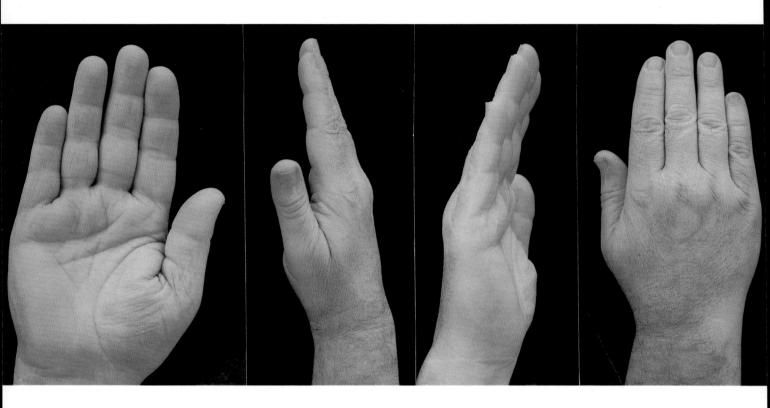

Study your subject. You can not carve what you do not know. Use your hand as a model if necessary. Open hand, four views.

Pointing hand

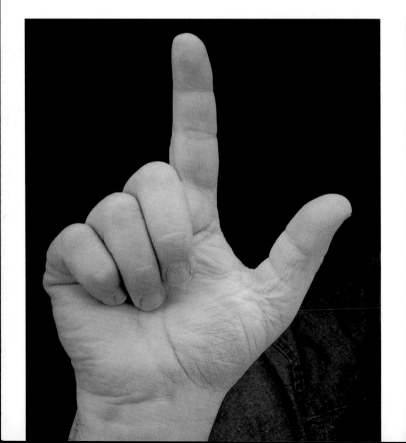

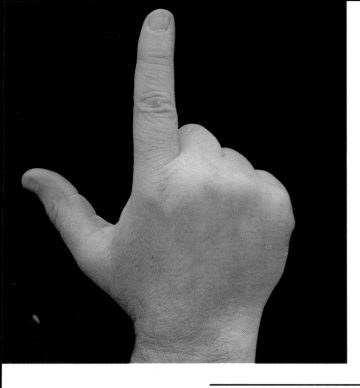
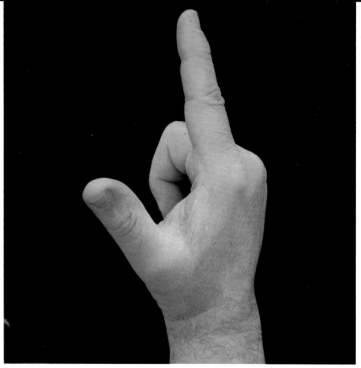

Fisted hand

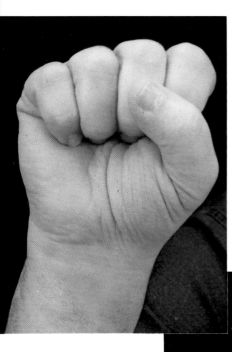
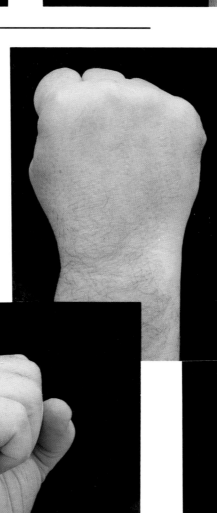

Holding hand

STEP ONE - Block out the hand.

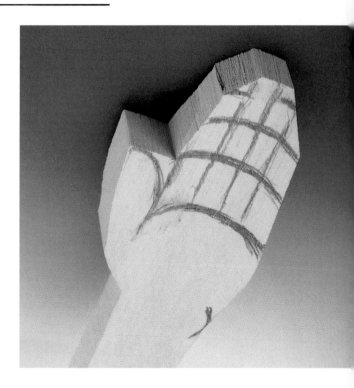

STEP TWO - Give consideration to the position of the hand and leave excess stock, especially on projects where the hand is in use (such as pointing, making a fist, or holding an object). Layout the individual finger shapes and contour (knuckle) lines.

28

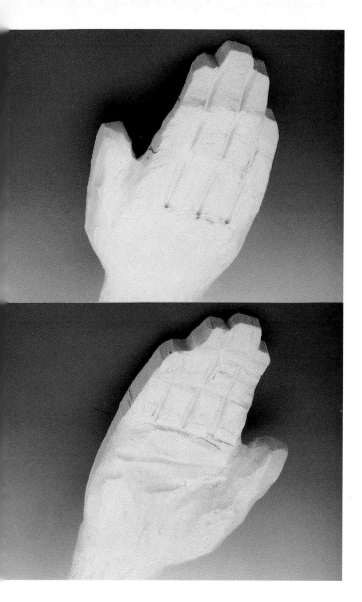

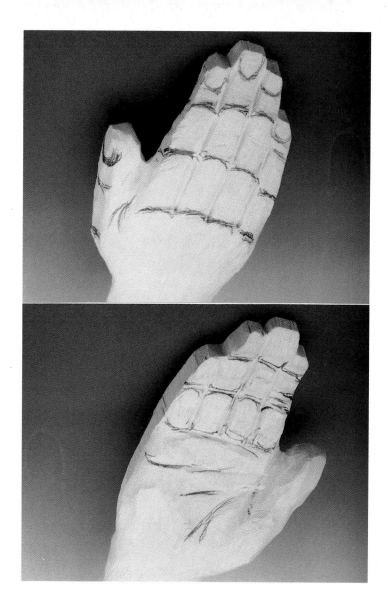

STEP THREE - Rough shape the hand on all sides, honoring the contour lines that the hand will assume in the final position. Always use a reference, either your own hand or photographs.

STEP FOUR - Locate and lay out all the knuckle arcs, fingernails, and palm.

STEP FIVE - Finish carve and detail the hand.

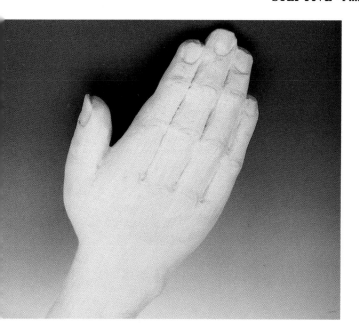

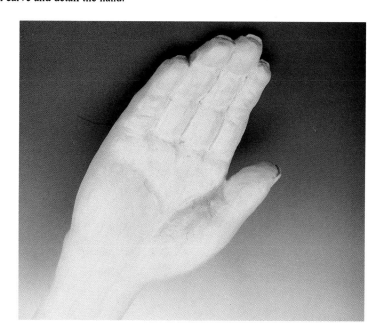

FEET, TOES & TOENAILS

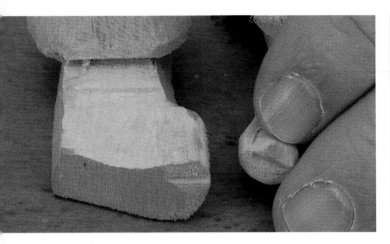

STEP ONE - Gather and study your reference material for feet. Block out the foot. Leave extra stock to facilitate the shape of the foot you are carving. The foot will have a very blocky shape at this point.

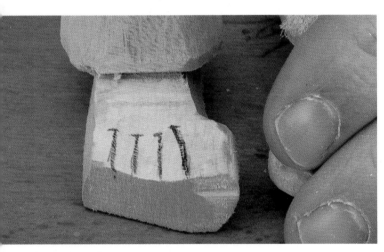

STEP TWO - Sketch in the toes.

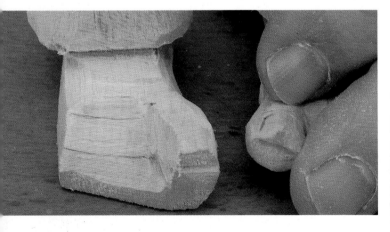

STEP THREE - Rough shape the contours of the toes.

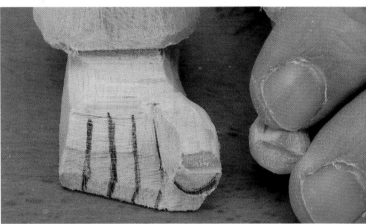

STEP FOUR - Layout the width of the toes and their placement on contours.

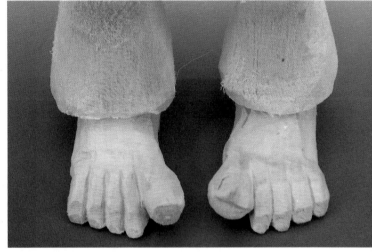

STEP FIVE - Block out, relieve, and rough shape the individual toes using a flame shape bit.

STEP SIX - Layout toenails and the details of the foot.

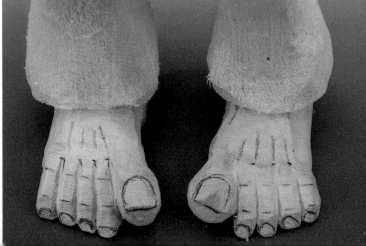

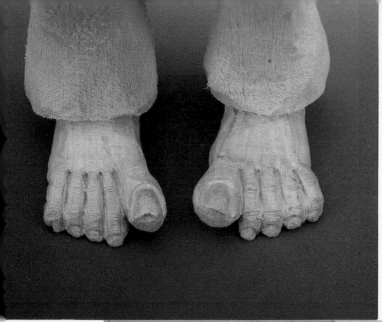

STEP SEVEN - Finish carving the foot.

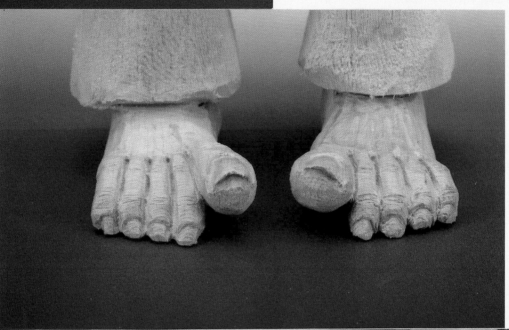

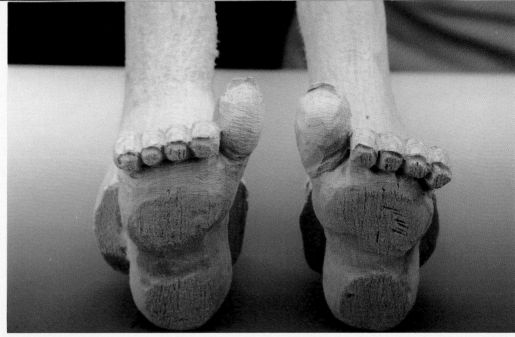

CARVING CLOTHING

BUTTONS

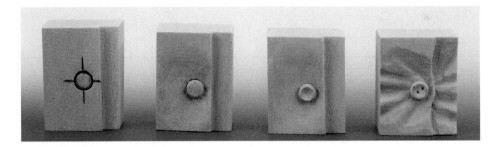

Carving sequence for buttons.

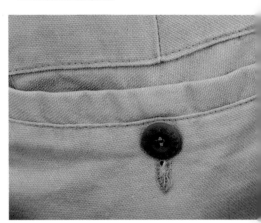

STEP ONE - Rough shape the area of the pocket to receive pocket details and/ or accessories (such as buttons, or handkerchiefs).

STEP TWO - Draw the extremes of the pocket.

STEP THREE - Once you've decided on the configuration of the pocket, relieve it away from the prepared area using the flame shape ruby carver.

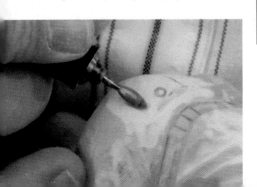

STEP FOUR - The shaping of the pocket is finished.

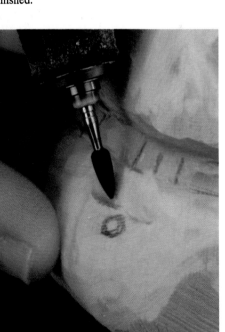

STEP FIVE - Deepen the opening of the pocket to give the pocket both some depth and a little mystery.

STEP SIX - Now we're going to put a button in. These are home-made button bits. The shanks of these bits are made with 1/8" brass rods onto which brass tubing (of the variety sized closely enough to allow one size to slip easily into the other) is attached. These tubes (available at hobby stores) have been silver soldered to the brass rod shafts. Note: You also make beads on jewelry with the same bits in a similar manner.

STEP SEVEN - Consideration must be given to the stress that the button is exerting on the material it is holding. Determine how you want to best exemplify this pressure or stress.

STEP EIGHT - Draw in the button. Notice how the stress lines have brought it to life and added authenticity.

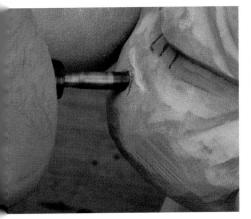

STEP NINE - Carve the button by pressing the button bit into the surface at the angle that you want the face of the button to be presented.

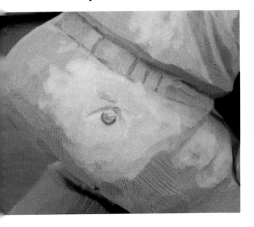

STEP TEN - Create the extremes for the depth of the button stress lines using the flame shape bit.

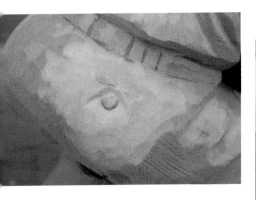

STEP ELEVEN - Relieve the button away from the pocket's surface.

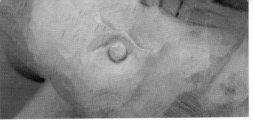

STEP TWELVE - Finish carving the detail of the pocket around the button. As you finish the pocket, make sure to include the stresses exerted on that pocket by the button - including the rise of material above the button.

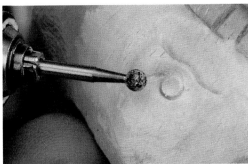

STEP THIRTEEN - Finish carving the detail of the button with a ball shape bit. Start by hollowing the center of the button.

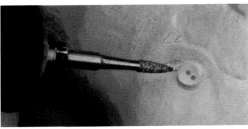

STEP FOURTEEN - Apply button thread holes with a small flame shape diamond bit. Your pocket is finished.

WRINKLES & CREASES

STEP ONE - Now we need to add some wrinkles to the rest of the clothing. Prepare the area to receive the wrinkles.

STEP TWO - Determine how the wrinkles are created by the stress introduced by the bend of the body. Draw the wrinkles.

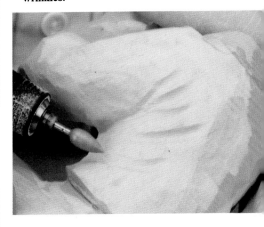

STEP THREE - Carve the basic wrinkle shapes with a flame shape bit.

Finish the wrinkle shapes, taking into consideration starting and termination points of individual wrinkles. Stay aware of the depth of a wrinkle at its deepest point where the wrinkle is most intense. Note how a wrinkle opens out at its end to blend or smooth back into the fabric. Add any additional wrinkles that seem necessary.

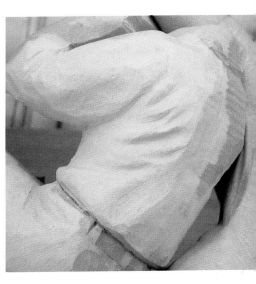

BOOTS, SHOES & LACES
BOOT CARVING SEQUENCE

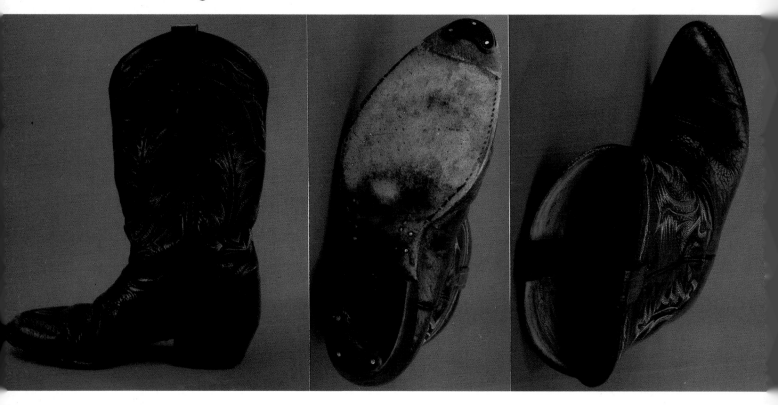

Although a cowboy boot was carved and referenced here, the same approach to any footwear should be used. View the subject from as many straight-on angles as necessary to familiarize yourself not only with the shape, but with the "personality" of the boot or shoe. Again, you can't carve what you don't know.

One trick to the cowboy boot, the fancy stitching up each side is not merely ornamental. It serves a useful purpose. The stitching braces the tall sides, eliminating the need for any interior support. Without this bracing support, the sides of the boots would gradually collapse around your ankles.

For clarity, the boot carving sequence shown is presented for a boot unattached to a leg; however, with the exception of hollowing a boot carved as a separate project, the steps remain the same as for an attached boot.

STEP ONE - Cut the side profile of the boot on a band saw. (This step and parts of STEP THREE will already be completed if the boots to be carved are part of a human figure blank).

STEP TWO - Establish the Centerline all the way around the blank. Sketch in the layout extremes of the boot from the front and the bottom.

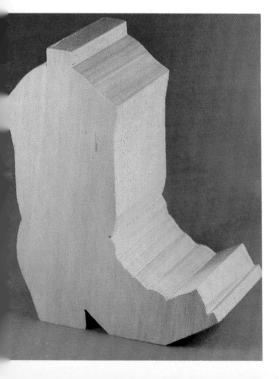

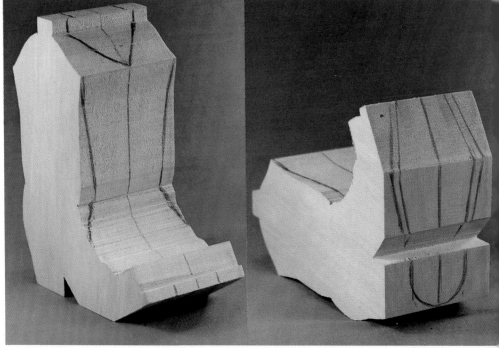

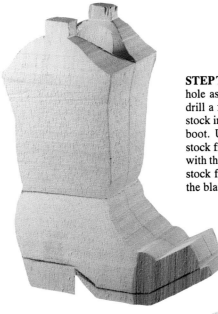

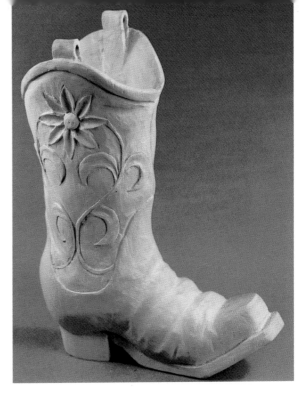

STEP THREE - Carefully drill as large a hole as is practical (use a Forstner bit to drill a flat bottomed hole) to waste away stock in preparation for hollowing out the boot. Using a band saw, remove waste stock from along the leg sides of the boot with the blank laying on its back. Remove stock from the sides of the boot toe with the blank in the upright position.

STEP SIX - Layout and carve the desired ornamental design. Use care with the layout to insure that the design is balanced and registered exactly the same on both sides and/or in front and back of the carving. Follow the contour of the sags and wrinkles as the ornamental design is being carved, or the boot will lose its personality.

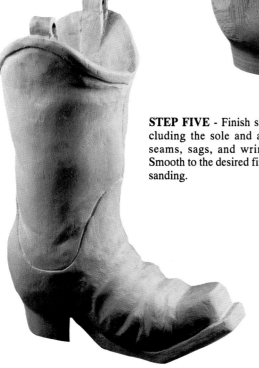

STEP FOUR - Honoring the centerline, rough shape the boot, leaving extra stock for any proposed designs and contours. Plan ahead for sags, wrinkles, and creases that occur naturally and are a result of wearing the boot. Rough out the interior, hollowing to the depth and shape desired.

STEP FIVE - Finish shape the boot including the sole and any straps, sewn seams, sags, and wrinkles necessary. Smooth to the desired finish with fine grit sanding.

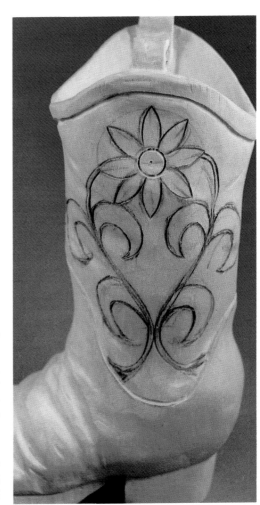

STEP SEVEN - The ornamental pattern for this project was first laid out with a pencil. The pattern was then adjusted until all sides were symmetrical, balanced, and accurate. Carefully outlined the pattern with a wood burner set at a very low heat. During both stock removal and the shaping of the design, the wood burned outline acts as a guide.

STEP EIGHT - Seal carving with several coats of your choice of a flat sealer (lacquer, varnish, or polyurethane), and allow to dry thoroughly. Leave carving natural or paint as desired.

Shoe Carving Sequence

For clarity, this shoe carving sequence is shown for a shoe unattached to a leg. With the exception of hollowing the inner shoe, these carving steps remain the same for an attached shoe.

Shoe laces.

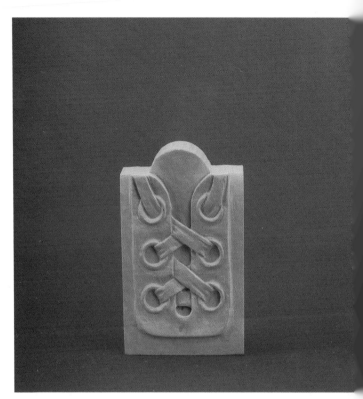

The carved laces.

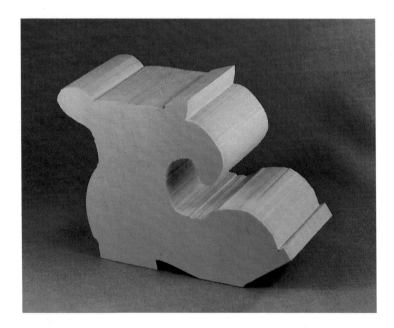

STEP ONE - Cut the side profile of the shoe on a band saw. (This step and parts of Step 3 will already be completed if the shoes to be carved are part of a human figure blank).

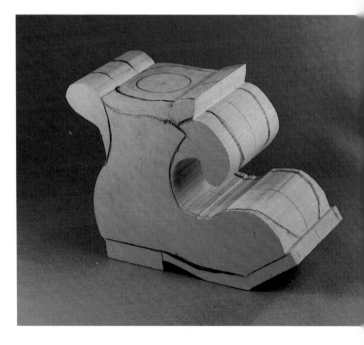

STEP TWO - Establish a Centerline all the way around the blank, then layout the details and extremes of the shoe over the entire blank.

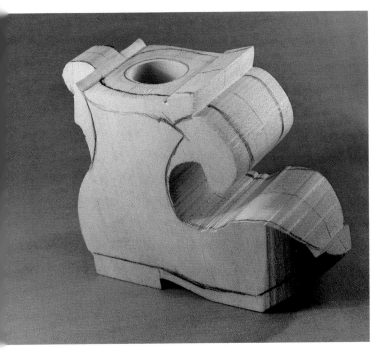

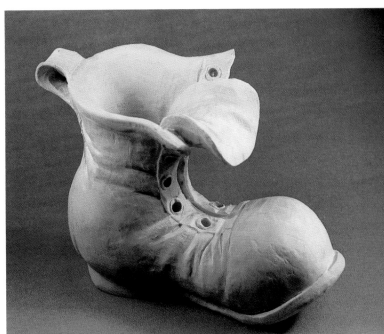

STEP THREE - Carefully drill as large a hole as is practical (use a Forstner bit to drill a flat bottomed hole) to waste away stock in preparation for hollowing out the shoe. Remove stock from the sides of the toe with the blank in the upright position. Block out the pull strap on back of shoe.

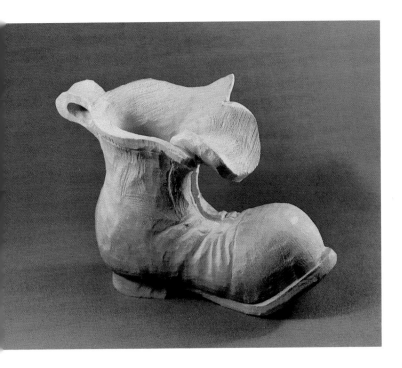

STEP FOUR - Rough shape the entire shoe, giving careful attention to the strap, tongue, eyelet strips, sole, heel, and creases. Shape the inner hollow of the shoe.

STEP FIVE - Finish carve the final shape of the shoe, then add the details including the eyelets and creases. Give the age to the project by adding rough scuff marks, dents, and sharper detail to the creases. Round the edges of the sole slightly to reflect wear and age. A hole through the sole, wear on one side of heel (usually the outside edge), and size numbers all add additional detail and personality. Seal the carving with several coats of your choice of a flat sealer (lacquer, varnish, or polyurethane), and allow to dry thoroughly. Leave the carving natural now or paint as desired.

PART TWO:
FOLK FIGURE CARVING PROJECTS

The project carvings are in various stages of completion to allow the carver to see how various aspects of the projects are laid out. This is a perspective the author feels is more important than finished views of a single carving.

GUARD CHICKEN

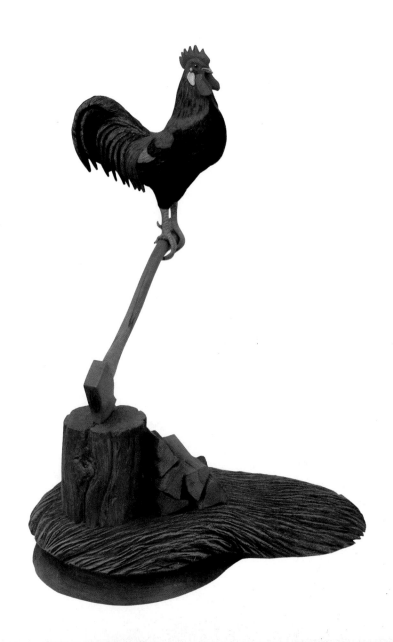

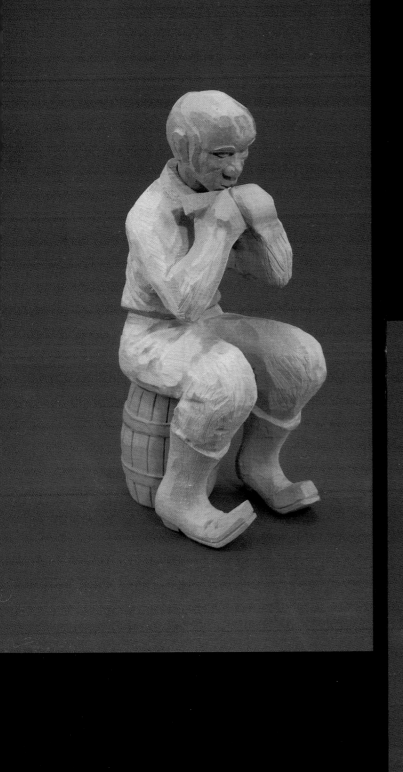
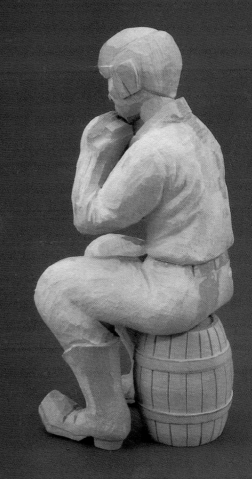

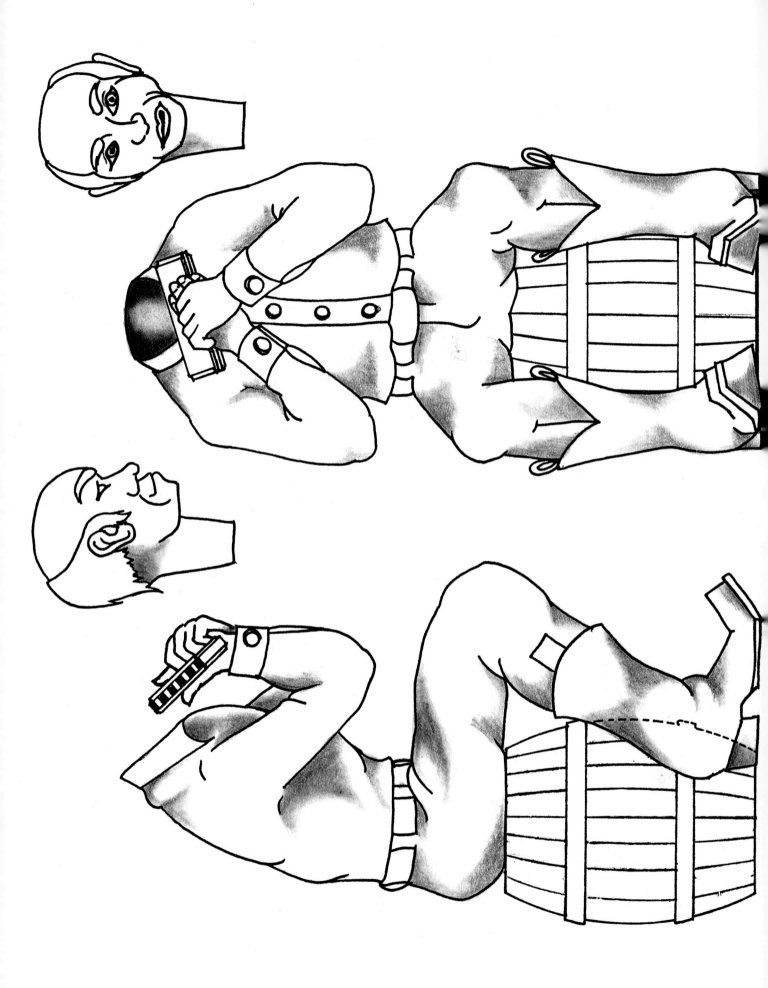

GUARD CHICKEN

I dropped Jim off a mile or more up river, as he preferred to fish downstream. My job was to find a spot to park Jim's car somewhere in between us, where it could be seen from the river, then walk down the road to the river and fish upstream, which was my preference. Years of fishing together would usually find us working our respective ways to the car within a few minutes of each other.

I parked the car at the far side of a driveway that ran between a house and the river. A pleasant looking man stopped playing his harmonica and returned my greeting as I approached.

"Louie! You sit still!", he commanded sharply.

I saw no other human, so I assumed he was talking to a dog that must have been lying well within the shade of the open side porch that ran the length of the house.

"Do you mind if I leave the car where it is for a couple of hours, while I fish back to it?" I asked.

"Go right ahead, young feller, and if you happen to catch a couple extra trout you'd care to part with, I'd cook them up for my supper, since the wife is away for the evening."

I assured him he would have a part of whatever I caught, and turned back to the car for my fishing gear.

"Dang you, Louie! I told you to sit still!", he shouted just as I felt a flapping rush at my hip boot. "Kick him good, young feller!, he thinks he owns the place!"

It took me several seconds to recover and realized that I was being attacked by a chicken! More precisely, by some breed of rooster that probably weighed no more than five pounds!

I gave the man a quick look to judge the sincerity of his direction to kick the feathered demon that was threatening the water-tightness of my boots.

As our eyes met, he shouted, "Give it to him!" So, with the hope that it was me he meant to be the giver, I literally gave Louie the boot.

As much as I care for all things furred and feathered, it gave me great pleasure to see that creature fly through the air as a result of my twenty-yard place kick.

"There! that should teach him for a while," the man said as the chicken ignobly rolled out of his tumbling flight, "I named him King Louie because he acts like this whole place is his kingdom. I had a cat, but it left after it couldn't stand any more guff from that crazy bird, ... and anyway, he guards the place better than that cat ever did."

It occurred to me that Louie guarded the place better than a killer dog or raging bull could, though I didn't say so.

"As long as I play my harmonica, he's stays right around me and sits just as quiet as can be, but the minute I stop playing, he's out patrolling the property. He has never once tried to pick my wife or me, and my wife can even pet him. We seem to be the only ones he likes - he even roosts right up under the porch roof at night."

I gathered my fishing gear and departed for the river, leaving Louie scratching about the yard, stopping occasionally to throw foul (fowl?) little threats and obscenities after me as I went.

When I returned, I noted from the road that the man had left the porch, and Louie was not to be seen. Rather than agitate the feathered monarch again, I went around to the front of the house and knocked to give the man the few fat Brook trout I had saved for him.

He received them gratefully, and I returned to the car where Jim sat pouting, giving me a hard look through the slightly opened windows. One wary glance revealed the reason for my comrade cowering in the car. King Louie sat perched on an axe handle by a nearby woodpile with a smile of absolute superiority on his little chicken lips.

"I wanted to slam his (bleeping) head in the door," Jim said with feeling. "You know that little (bleep) chased me right into the car?"

All of this from a man I had not heard curse more than twice in our twenty-nine year friendship!

As quietly and unobtrusively as possible, I folded myself into the car, and we departed, leaving "His Royal Featheredness" to continue his reign of terror in peace.

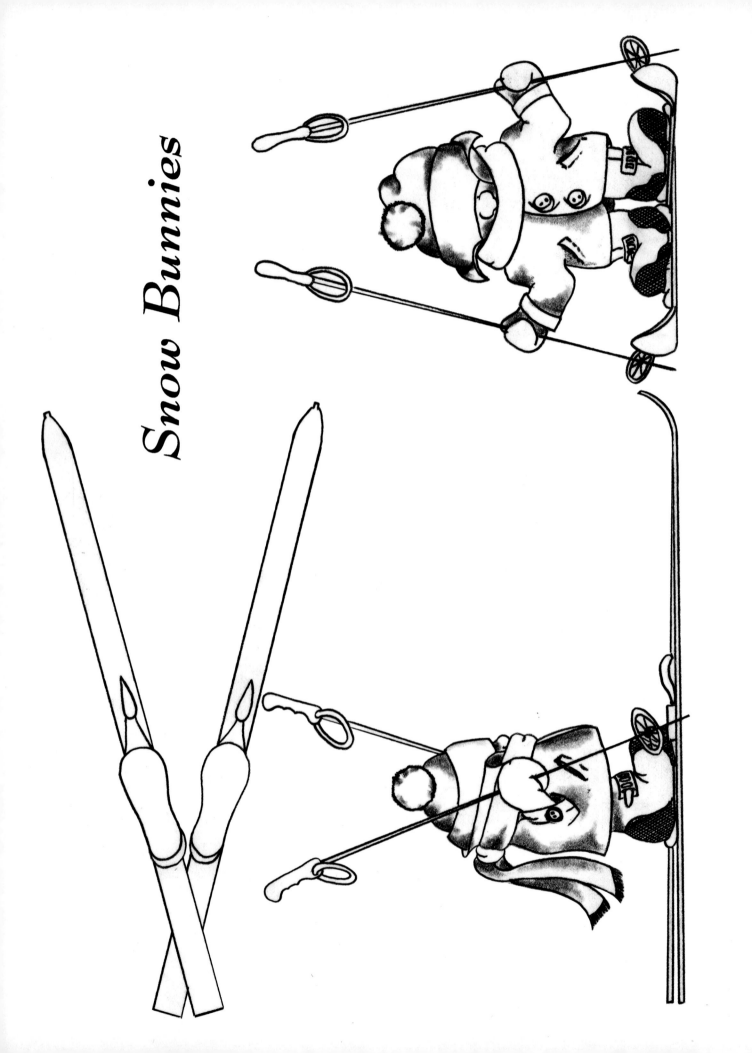

Snow Bunnies

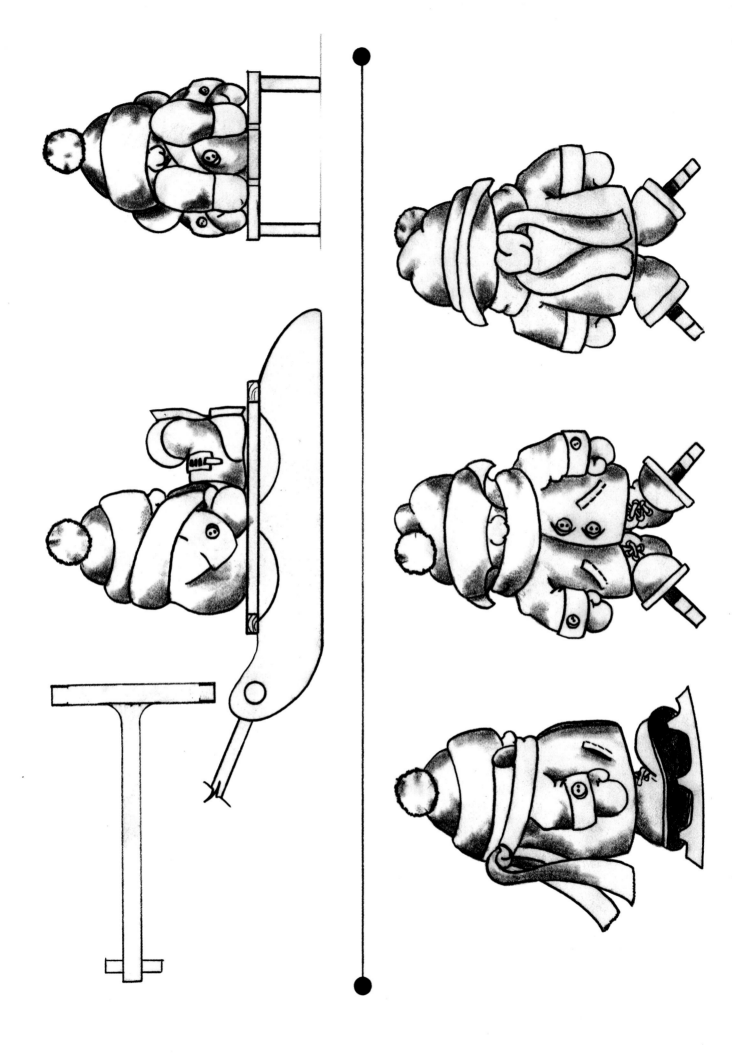

Snow Bunnies

My wife and I had just moved into the first house we ever owned in South Burlington, Vermont. The two bedroom home was small but it was ours, lock, stock, and mortgage. Our newly born first-child had a home to call his own, and his parents would have a bit of equity instead of twelve rent receipts to show at the end of the year.

The neighborhood was crowded. The house lots were long and narrow, and though the houses were well built, I think realtors today would call them "starter" homes.

There were little children everywhere! Halloween was a confectioner's dream. We never knew how much candy to get for the trick-or-treaters ... we just knew we should get a lot.

Most adults were working parents. Although adult might only know adult as a passing acquaintance, everybody knew each neighborhood kid by name, who the parents were, and where the kid belonged. The street was amazingly quiet, all the children were watched and cared for no matter where they were. If your child was playing at a neighbor child's house, you knew that he was watched and as secure as if he were in his own yard. The reverse held true when your child had visitors in his or her yard.

We loved watching the children grow, but enjoyed watching them through the seasons. Winter was the greatest time of year for kid watching. When it was cold and the snow was deep. most of the little critters were bundled beyond recognition. A little protruding nose, or bright little eyes showing from the depths of a knitted touque or stocking cap might be all there was to indicate that something alive resided within. My wife called them Snow Bunnies because they were soft, puffy, and so cuddly she always wanted to hug one or all of them.

With hand-me-down or "recycler" clothing, child identification from year to year was almost impossible. Hand-me-downs were passed from older to younger children in the same family. Recyclers were passed from an older or larger child in one family to a younger or smaller child in a neighbor family, so you might see the same parka, scarf, or hat for years, but on a different child each year.

Hand-me-downs applied not only to clothing, but to expensive equipment such as skates, skis, and sleds. For some reason the winter equipment never seemed to fit at the right time. By the time a boy got his brother's hockey skates, they would still be much to big for him, but by the next winter, he would have outgrown them.

Still, no matter the size, these items were worn and used when received.

On one occasion, we heard great clomping and clattering on our steps. When we went to the door, there stood a bundle of clothing clutching a hockey stick and wearing skates at least twice as long as his little feet. Standing erect on the blades was either impossible, or had been abandoned, because the skates lay sideways to the point that the inner edge of the soles and the sides of the blades supported the wearer. He had already traveled a fair distance, because he lived at the far end of the street. It broke my heart to tell him that our son wasn't at home to go "skating" with him.

We once drove into our drive with the weekly groceries and found a bundle on huge skis with man-sized ski poles standing on the snowy sidewalk across the street. We unloaded the car, put the groceries away, and went into the living room to enjoy a cup of tea. My wife looked across the street and there stood our skier in the same position. A few more minutes passed, and still our nordic adventurer did not move! Finally, I went across the street to check, and heard tiny sobs and sniffles coming from the folds of a scarf. He had crossed his skis behind him, and was standing with them one atop the other in such a manner that he couldn't move or didn't know how to move without falling over. How long he had been standing there we never knew, but when I helped him out of them and brought him down the street to his home, his mother said he had been gone for over an hour.

Snow Bunny with Skis.

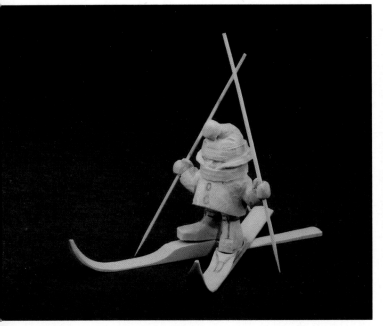

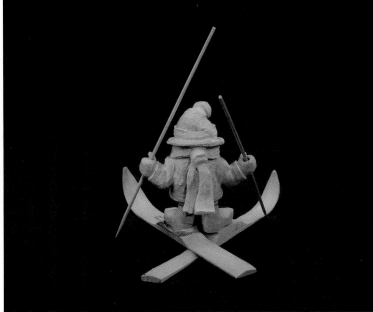

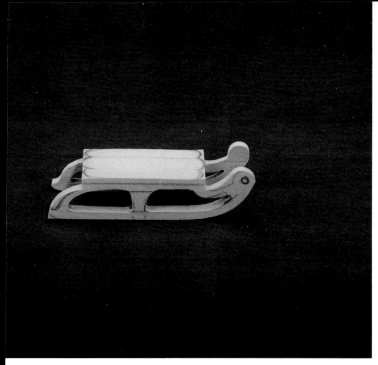

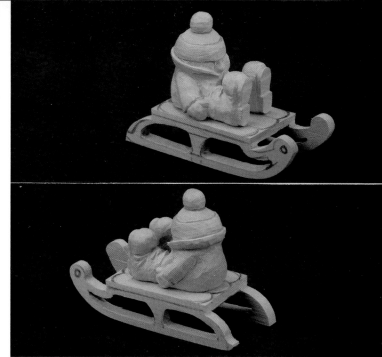

The Sled

Snow Bunny on the Sled.

SNOW BUNNY SKATER

STEP ONE - Cut the carving blank two ways on a band saw and establish a centerline.

STEP TWO - Lay out the lines for the major contours (rely on pencil marks and register marks made by band sawing the blank).

STEP THREE - Block out the major contours.

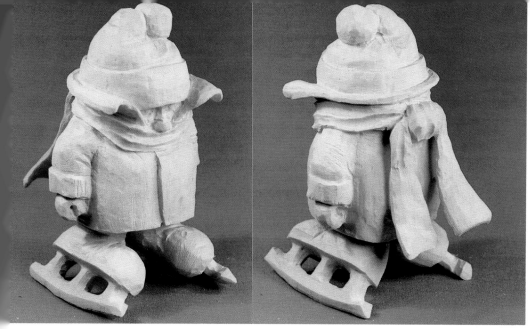

STEP FOUR - Rough shape all the major contours.

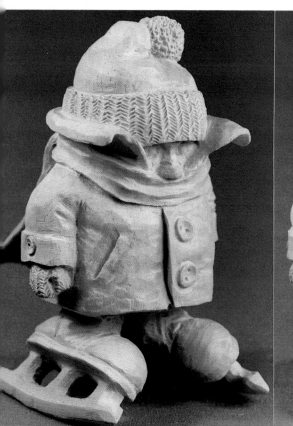
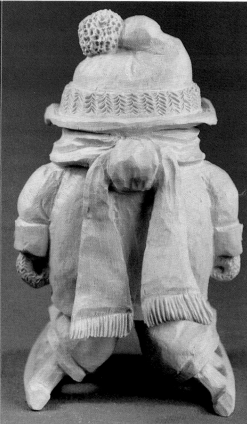

STEP FIVE - Finish shape and blend the areas together. Add the finish details (wrinkles, pockets, buttons, cloth texture, laces, etc.). The fringe on the end of the scarf in the back was textured with short matching parallel strokes using the sharp edge of an inverted cone shape stone bit.

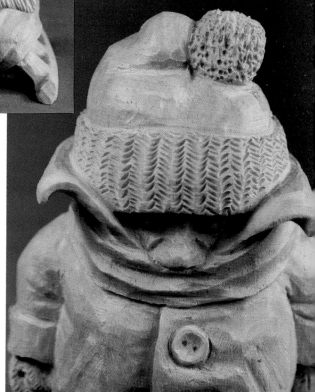

STEP SIX - The ball tassel on the touque (hat) was textured by driving the tip of a small flame shape ruby carver straight into the ball at all angles. The knitted texture on the hat band and mittens was accomplished by alternating rows of single cuts by touching the sharp edge of a small inverted cone shape diamond bit.

STEPS SEVEN & EIGHT - Seal your carving with several coats of the flat sealer of your choice (lacquer, varnish, or polyurethane) and allow to dry thoroughly. Leave the carving natural or paint as desired.

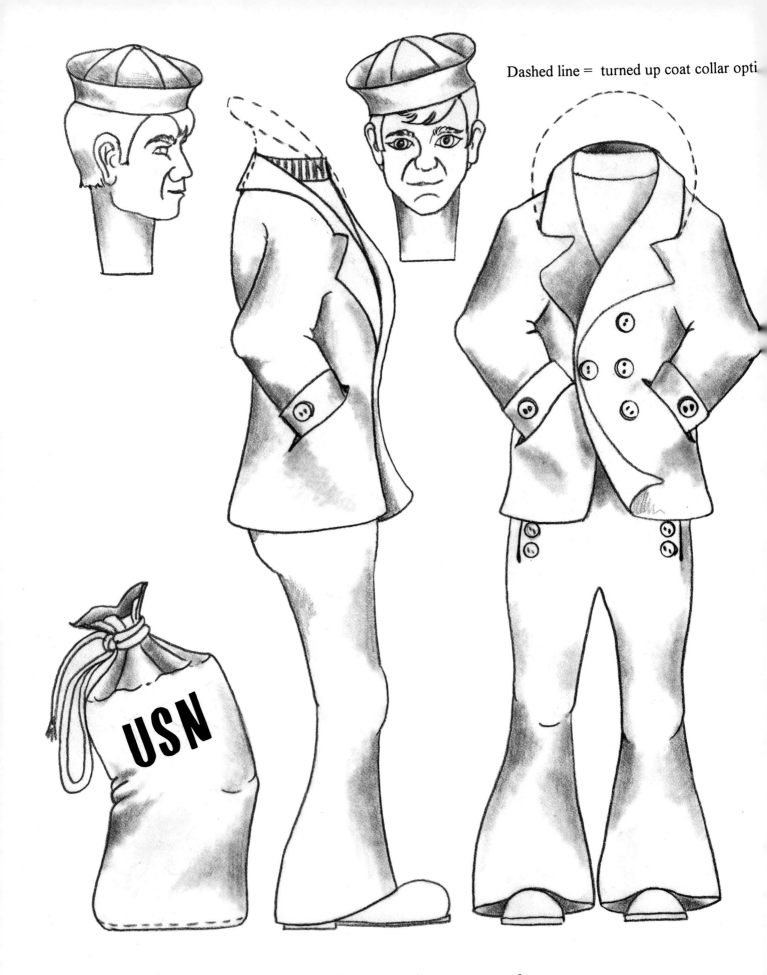

Dashed line = turned up coat collar opti

USN

Inland Sailor

INLAND SAILOR

The wind howled and the snow swirled around and down into the large turned-up collar of his pea-jacket. The sailor's white hat amounted to very little against the freezing wet onslaught that blew against his face and head. Perhaps the choice to hitch-hike and save the bus fare money the Navy had allotted him hadn't been such a good idea after all. Oh well, ... Mom could use the money he had saved by not taking the bus.

He decided to walk along the road for a while - anything was better than standing in the bitter cold and freezing while he waited for a car to come.

The lights of my car illuminated the dark figure struggling to throw his sea bag on his shoulder and thumb me down at the same time. I had been driving for the better part of six hours and it had just started to snow in earnest when I saw the young sailor through the snow streaked rays of the headlights.

"I'm going as far as Burlington," I said as I stopped the car beside him.

A grateful sigh escaped his tired face.

"That would be wonderful!" he said, "I've been out here for over an hour and a half with no luck. I'm trying to get home to Shelburne, and you'll have to go right through it!" He struggled to get his sea bag and an overnight bag quickly into the back seat, and we started off into the night.

"What in the world are you doing out here in the middle of nowhere at this time of night?" I asked, after we had exchanged introductions.

He explained that he was on the way home after having been released from the Navy on a "hard-luck" discharge. His Father had died, leaving his Mother with no means of support and unable to run what was left of their farm. It was up to him to care for and support her.

"How do you feel about that?" I asked.

"Well, I could send her what money I make in the service, but if I don't get back to running the farm, which has been in the family for generations, we'll lose it. In a way, I hate to think of going back, 'cause even though I'm from a mountainous state like Vermont, I love the sea ... I love water of any kind. That's why I chose the Navy in the first place. Oh well ... part of the farm borders on Lake Champlain, so at least I'll be near water."

We talked all through the remaining three hours that it took to reach Shelburne. I was in no particular hurry, so I delivered him to his home, where I enjoyed a cup of coffee and a piece of pie with him and his mother.

Several years were to pass, and I was trying my luck troll-ing for the salmon, lake trout, and wall-eyed pike that abound along the Shelburne-Charlotte section of Lake Champlain. As is often the case, the wind comes up with little warning and the waves began to toss my little fourteen-foot boat about like a Frisbee. I headed for shore as quickly as the waves and my little twenty-five horse power engine would allow, and shot into a protected cove where I noted two charter boats just tying up.

"I wonder if I could tie up here until this blows over?" I asked the muscular young man with "Captain" written on his jacket.

"You sure can," he said with a friendly grin. Then after a few seconds, "HEY! I know you! You gave me a ride home from the Navy one night! How have you been?"

Finally, recognition came to me, and we shook hands as I climbed up on the dock.

He finished with his charter people, gave the boats a final check, and I joined him, his mother, and a new wife over a cup of steaming coffee.

I remarked on the beauty of the farm as I gazed out over the rolling acres through the spacious kitchen windows.

"It was tough going for a while, and we're still not out of the woods, but between the farm and the charter business I've started, we should be in good shape in a few more years. I've got the best of both worlds and we're still afloat!" he laughed.

"Well, I'd like to help keep you going by hiring a charter the next time out," I said.

He looked at me seriously, and said,"That trip will be on me, I owe you that and more. I still remember the night when you kept me from freezing to death."

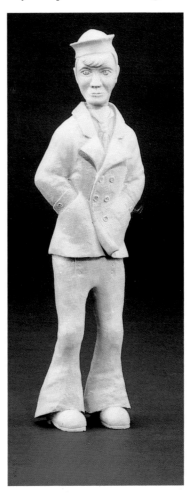

Inland Sailor.

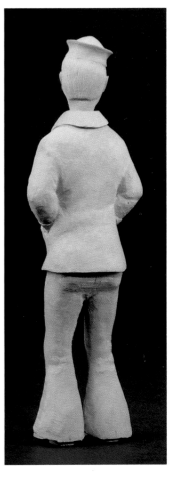

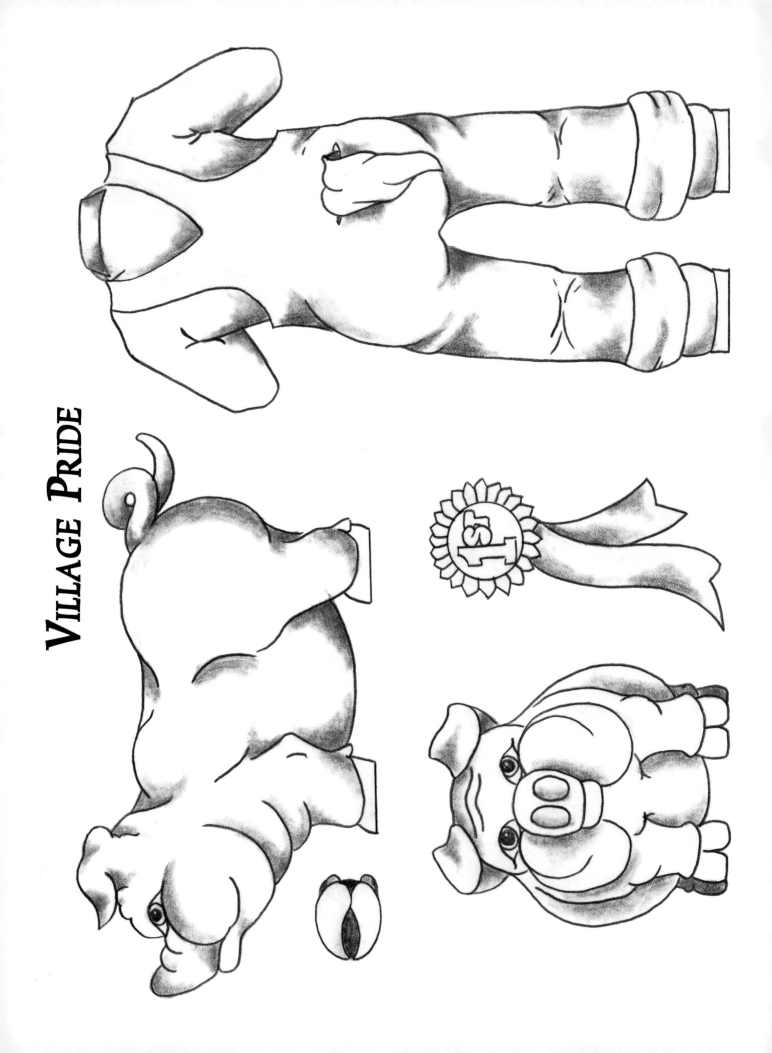

VILLAGE PRIDE

Pig Farmer.

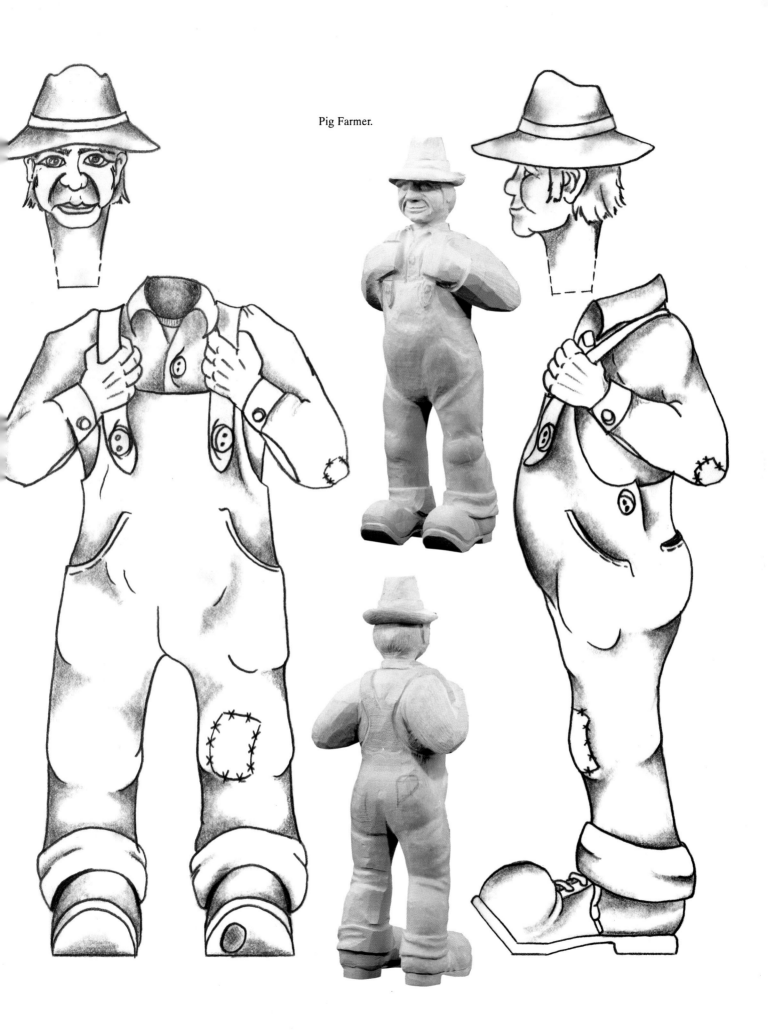

VILLAGE PRIDE

The "out-of-stater" purchased thirty to forty acres of land abutting the only road out of town leading to Mount Mansfield, touted as the ski capitol of the East. His plan was to build a complex complete with rooms, restaurant, lounge, and other attractions necessary to house some of the thousands of skiers and summer tourists that passed through the village daily enroute to the slopes and lifts.

All went well until he submitted his proposal to the zoning powers. He was rejected. Evidently, that parcel of land was zoned for agricultural use - no matter that ski houses already existed above and below the land for miles, that better than ninety percent of the whole road was commercial, or that there hadn't been an active farm on that road for years. That land was zoned agricultural and that was how it would stay. Besides, the zoning board added with a sniff, there were already enough ski houses and dorms on the mountain road. If he wanted to use the land, it would have to be an agricultural use.

What happened next was to be the topic of conversation for weeks, and for miles around. The "out-of-stater" built a fence around the parcel, located an unsightly old mobile home at the entrance for his caretaker, and let loose a herd of close to one hundred of the biggest, fattest, most odiferous hogs to be found anywhere. Huge mounds of dirt were placed at various points around the property, and the hogs sprawled out in voluminous piggy resplendence along the tops of these to sun themselves in full view of the restaurant and other businesses across the way.

To insure that no one could miss the fact that this was indeed an agricultural venture, huge truckloads of chicken manure were spread along the entire strip of land between the fence and the roadside right-of-way, two or three feet deep, allegedly as fertilizer. Soon the pigs and chicken manure began to work their magic. When the wind was right, the agricultural "perfume" permeated and penetrated the valley.

We took the family to see and photograph the curiosity, and the caretaker seemed not only interested, but proud of his charges. He allowed that given time and money to do so, he could make the pig farm a profitable venture.

Apparently he was given neither, because some months later as we had occasion to pass that way, the pigs had disappeared, the chicken manure was covered with weed stalks, pig houses were disassembled, and the gate was down.

What happened to the chubby residents who, among others, were christened Hammy Faye Bacon, Captain HAMerica, and CHOPsticks. Have they already graced a dinner table?

To date, nothing has been heard which explains why the operation stopped, although there are rumors of lawsuits and countersuits between village and owner.

The land lies quietly dormant, awaiting a richer reputation than a song, a poem, and a commemorative poster about pigs.

Village Pride. The pig in all his splendor.

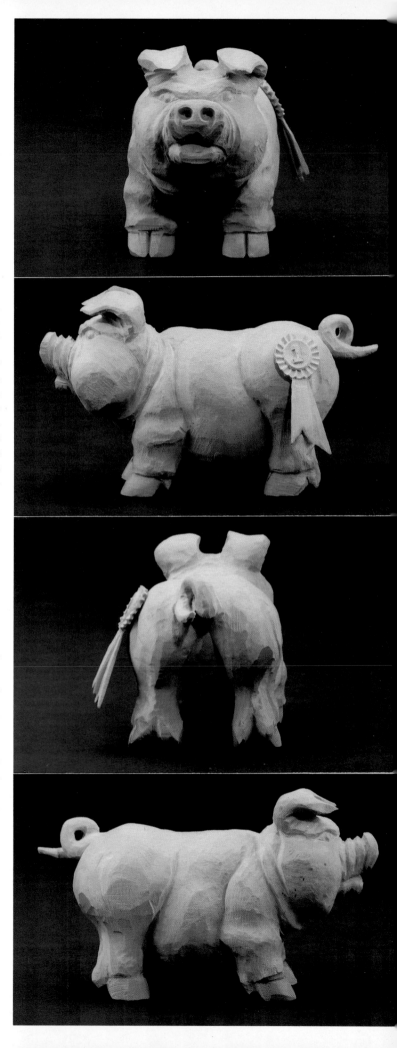

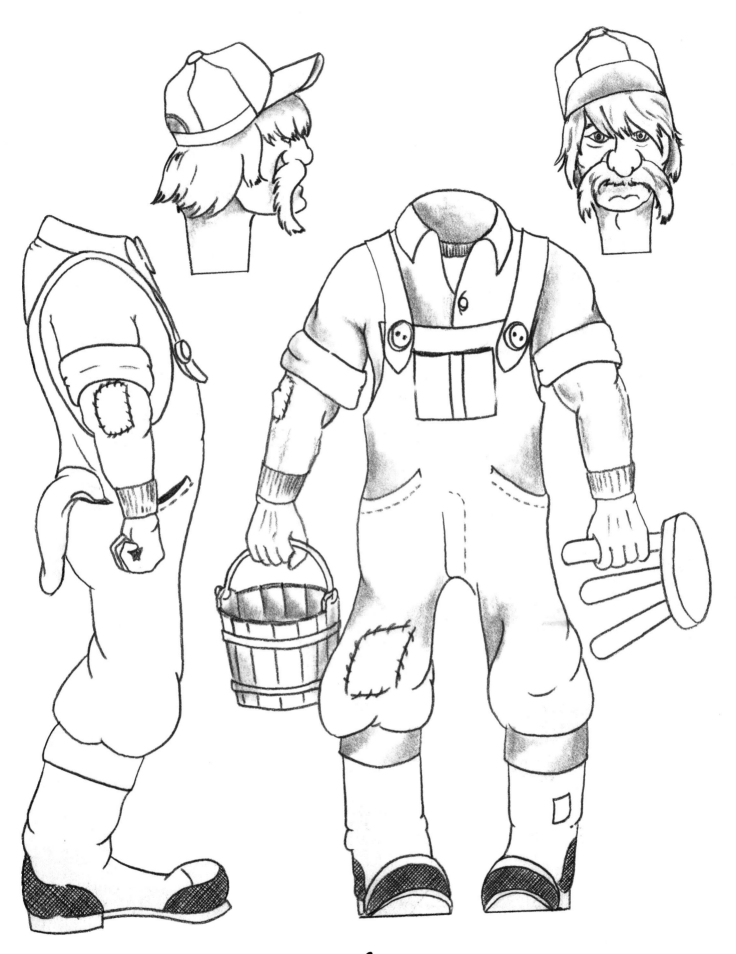

The Family Cow

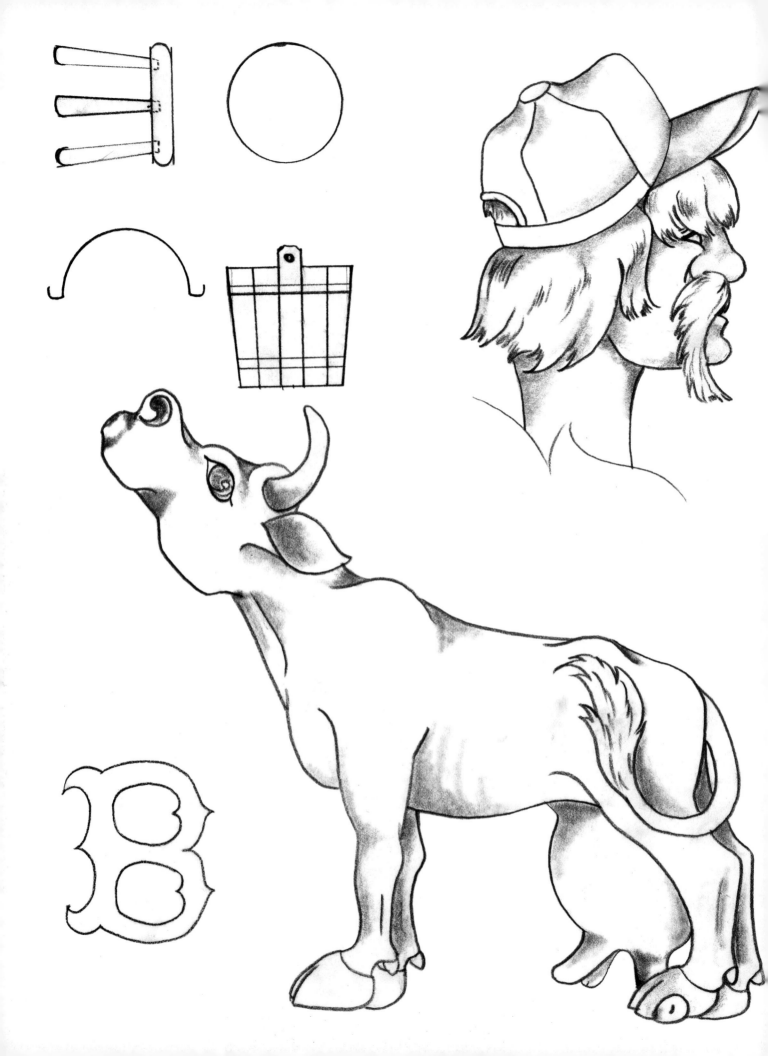

FAMILY COW

Recently, I had occasion to speak to an enchanting group of youngsters in the fourth grade. I told them stories of how my carvings came to be and the people and animals they represented.

I was amazed to find through conversation that many of those little ones had no conception as to where milk, eggs, meat, and the like actually came from.

I was informed that milk, eggs, and meat all came from the grocers in cartons and packages - how it got to the grocer's in the first place no one was absolutely sure, but some of the suppositions were priceless.

I thought of my Grandfather and the generations before him who had never seen a cardboard milk container or known the convenience of a grocery store, as we know it.

Every day the routine was the same, for over forty-five years Granddad performed the same "chores," as did thousands of others like him in similar rural communities. Arise at four A.M., out to the small barn, feed the one cow, the pigs, and chickens, gather the eggs, then milk the cow. After, it was off to the house, strain the milk, put it in the cooler, wash up, have breakfast, and leave for the day job.

An hour's time invested at each end of the day provided milk, cheese, butter, eggs, pork, hams, bacon, sausage, chicken meat, and beef. A huge summer garden provided fruits and vegetables that were canned and preserved in quantities that would last the family through the following year.

In their season, wild berries and fruits were gathered, as was the wild game such as deer, turkeys, ducks, and geese. All provided a healthful and bountiful repast for the family.

Of all the chores and animals dealt with to provide sustenance, the favored one was the Jersey cow that was kept for milk. The gentle disposition, the large soft brown eyes, and her response to his quiet and kind treatment made her as much or more of a pet than any of the many cats that lived in the barn and mooched their daily saucer of milk.

At every milking, there was a choice tidbit that was hand fed, or a gentle petting along her neck and flanks that made her content and put her at ease.

Each cow kept through the years was said to be his favorite, and gave the richest creamiest milk - except one. For some reason, all were named Mabel, except this older cow he bought once that was already named Bonnie.

Bonnie was a large cow, gave a great quantity of milk, and had a huge udder. Once, while lying down, she stepped on one of her teats as she arose, and from that day forth, she was a problem to milk. All the soft talk and petting was for naught by the time he reached for her udder. Though she never tried to kick, she shied as far away from him as her stall would permit, and would then jump as far backward and forward as her stanchion would allow.

Finally, Bonnie was sold, and another Mabel replaced her. Years passed, and Mabel was replaced by Mabel after Mabel until Granddad could no longer walk out to the barn.

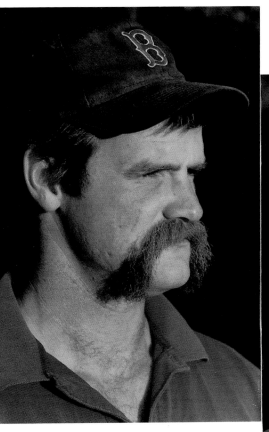

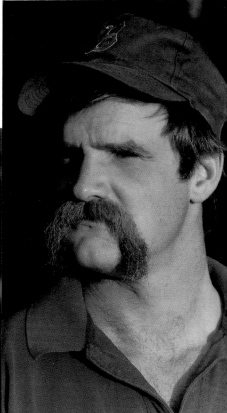

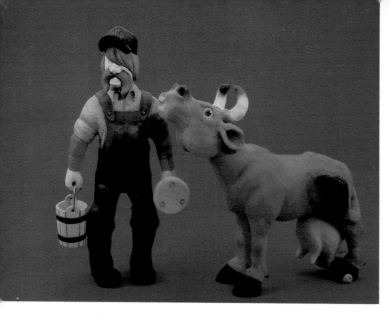

The Farmer and Bonnie, the Family Cow.

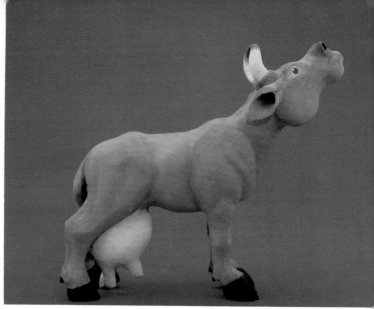

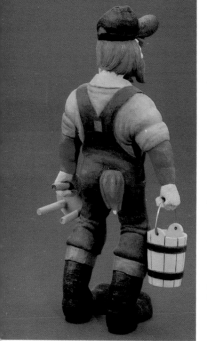
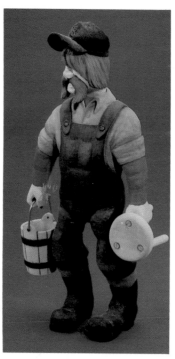

The Farmer

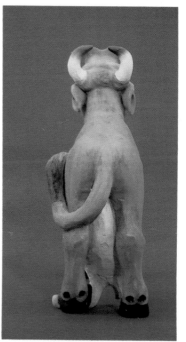
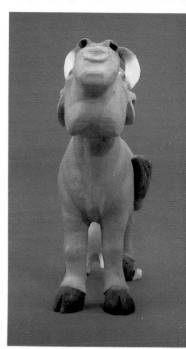

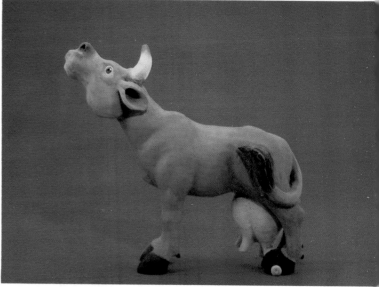

Bonnie and Her Predicament.

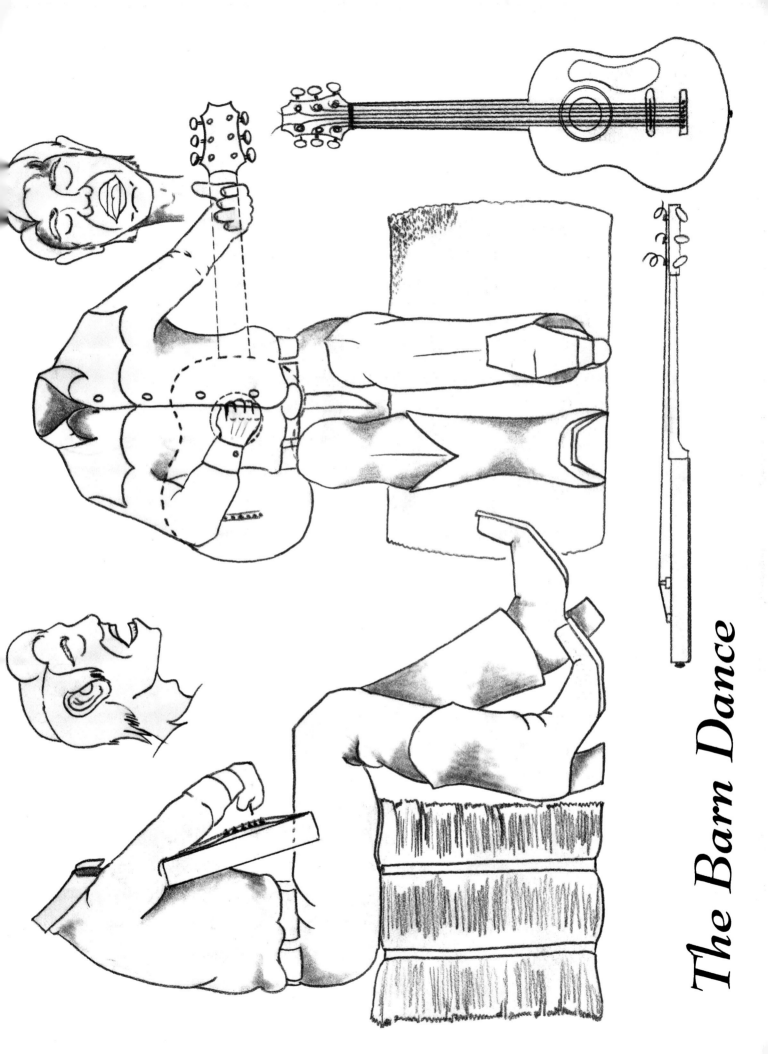

The Barn Dance

BARN DANCE

At one time, the old barn had housed over one hundred big black and white Holstein cows, each giving her milk twice a day. The lights went on at four A.M. for the morning chores, and four-thirty P.M. for the afternoon chores.

The routine repeated itself daily for father and son through four generations, until the last generation son left for a more lucrative city job, taking further success for the farm with him. His parents and their daughter remained, but due to the father's periods of ill health, long and passionate discussions regarding the sale of the farm arose. An auction soon took the herd and equipment, leaving the barn, out buildings, and meadowlands empty. Only the house continued to show signs of life. Still the patriarch could not bring himself, surrounded by his memories and the spirits of those long gone, to sell what remained of a long family tradition.

At the conclusion of one particularly exhausting debate, the older man left the house and took the well worn path out to the empty barn. Wife and daughter watched the broad-shouldered back as he wended his way, perturbed and weary, to the barren building.

An hour passed before the wife decided to follow and sooth feelings that may have been hurt. As she drew near the barn, she heard the melodic strains of a sad old waltz, created by a quiet guitar and accompanied by a familiar pleasing voice, coming from the upper level of the barn where the hay had been stored.

She changed her route so as to enter through the great doors that hung open at the upper level. Seated on a bale of hay with his back to her, sat her loving spouse of forty years, quietly playing his guitar as he faced the cavernous emptiness before him. The music stopped, and without moving his head, he said, "Come dance for me, Dear. You were such a lovely sight when we danced."

She moved in front of him as he began to play and sing again.

She curtsied with a poignant smile, then holding her skirts daintily off the floor, she began the graceful turns and sweeping maneuvers of a waltz with an invisible partner.

Each time she neared him, she averted her head so he wouldn't see the tears that streamed down her face.

Suddenly the music stopped.

"That's it!" he exclaimed, "that's how we'll make it pay, and keep what's left of the farm! We'll hold a barn dance every Saturday night, and charge admission."

He gathered her up in his arms, and whirled her around and around.

Within a few weeks, the barn's upper level was prepared for its new function, and the old barnyard in the rear was filled and graded into a parking area.

For years thereafter, the barn earned more in one night than had been earned by farming seven days a week.

Barn Singer, quarter views.

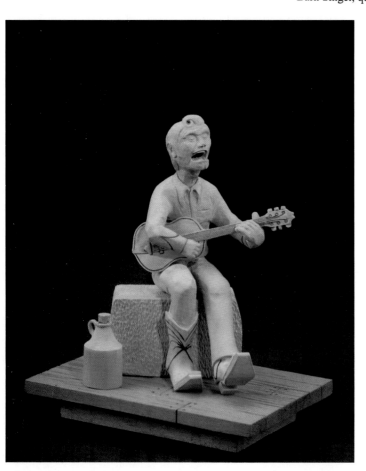
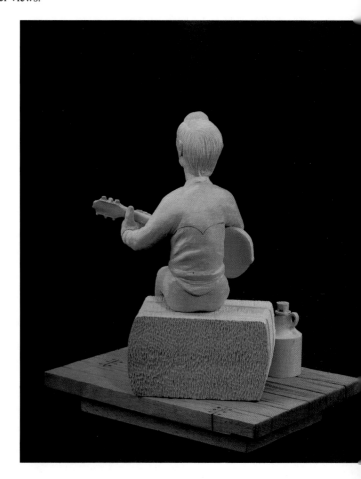

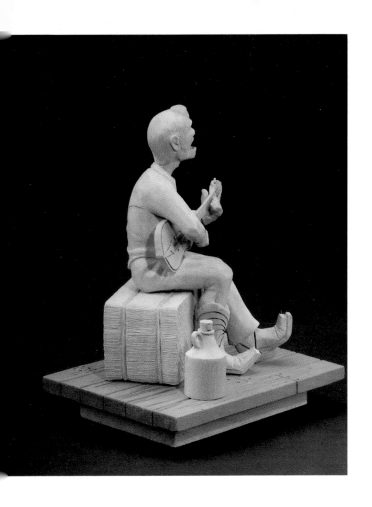

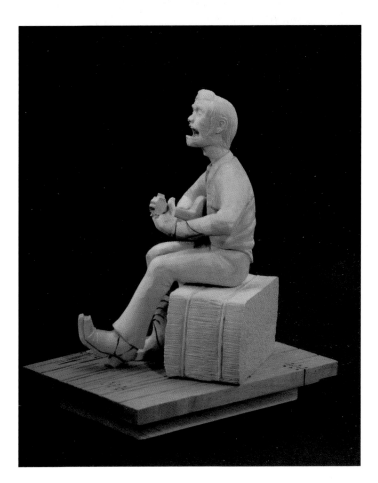

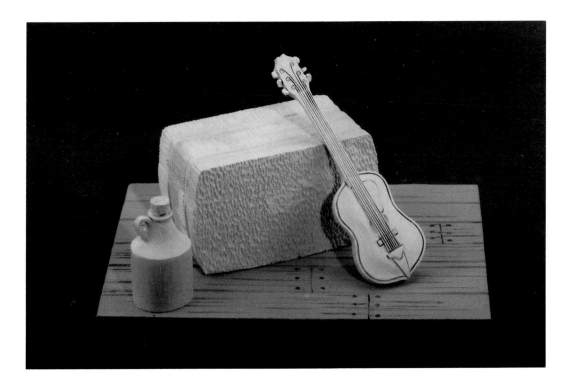

The Singer takes a break.

Circuit Preacher

CIRCUIT PREACHER

My three and a half year old granddaughter climbed up on my lap and cuddled into the curl of my arm. I looked down on the golden brown curls nestled at the base of my shoulder and kissed the smooth vibrant little forehead. The blue eyes met my gaze and she asked, "Grandpa, what does death mean?"

Death was the last thing I wanted to consider, let alone explain, as I sat emersed in the radiance of so precious a child. Quietly, the wide innocent eyes studied my face as I contemplated what to say. I'm sure she sensed the emotion I fought to control as I thought of a beloved friend of thirty years who had very recently died, and whose passing I suspect had prompted the question.

We rocked quietly as I searched the murky depths of memory in a frenzy to pull some incident from my past that would best and most gracefully describe so dreadful a subject.

Slowly from the mist of time came the image of a man I'd met only for a few minutes when I was five or six years old and never saw again. A man who gave me a message about death that has stayed with me ever since.

My Grandfather called him the "circuit preacher." He was seen from time to time either delivering a "fire and brimstone" sermon in a tent or barn, or conducting a wedding or a funeral somewhere along a forty to fifty mile course, or "circuit", of towns.

My grandparents and I were attending the funeral of a close friend of theirs, and the circuit preacher was there to conduct the outdoor service. It was the first funeral I had ever attended, and after the gladness of seeing so many friends and neighbors wore off, I became aware of the grief that surrounded me. I squeezed very close to my grandfather, grasping his huge hand tightly with my two small ones. I felt no sadness, no bereavement, no grief. I felt only an engulfing fear. My grandfather soon sensed my distress, and after the service suggested that we go look at the preacher's horse, a beautiful arch-necked, chocolate Morgan.

We approached the animal at the same time that the pastor did, and I petted the horse as the two men exchanged greetings and conversation.

"His name is Moses, and he must like you or he wouldn't let you pet him on the nose like that," the pastor said. For the first time I took notice of the tall auburn haired man in the green velvet waistcoat and grey riding trousers.

"Your Grandfather just told me that something frightened you badly here today, ... can you tell me what it was?"

It soon came to light that all the people crying over the dead man had scared me.

With quiet and sincere words meant for me alone, he explained how I shouldn't fear death, because our bodies are just temporary houses for our souls. When our souls get old enough to go to live in God's house, He calls them and we must leave our body houses behind. He explained that God also sends a Guide, someone that loves us and has gone before us, to meet our soul as it leaves its body house. They walk with us to see God through a beautiful white light that fills us with well being and love - and we never know fear or bad things again.

"The people cry because it makes them feel better after a while, just like you do when you fall and hurt yourself. Don't you feel better after you cry a little?" he concluded.

Hard as it was for a seven year old to admit, I nodded, remembering times when I had fallen and cried.

So it was that the circuit preacher and I explained death to my granddaughter.

"Will you die, Grandpa?"

Yes, I will, Julia, but let's save that for another time.

Circuit preacher.

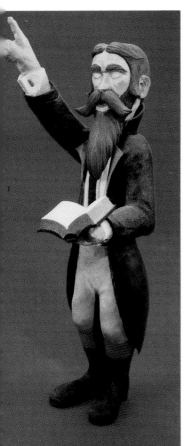

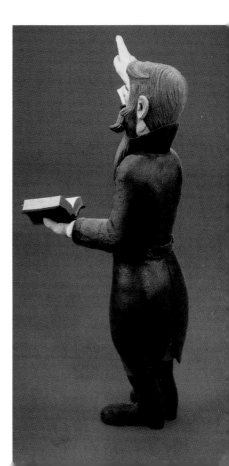

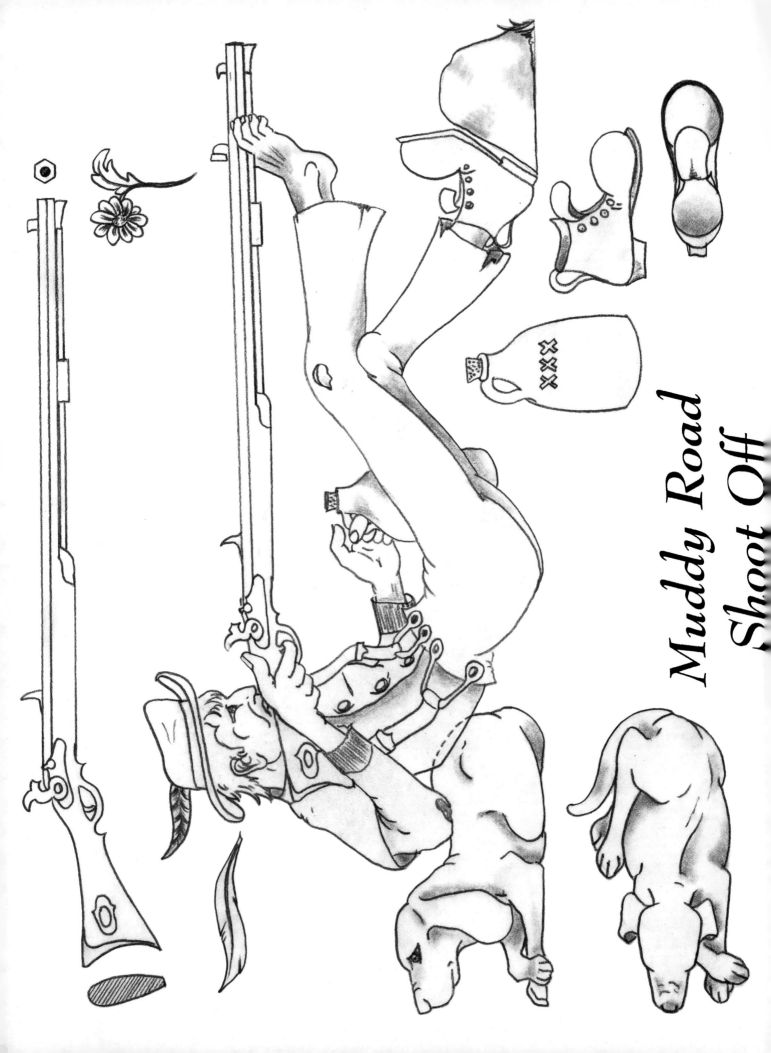

Muddy Road
Shoot Off

MUDDY ROAD SHOOT OFF

The Muddy Road Shoot Off is the last pictured project in the book. It is the most complex and challenging.

Clyde and Angus were brothers who loved to hunt, fish, and shoot. Beyond the bickering and the jokes they played on each other, they appeared genuinely fond of each other ... until it came to admitting which of the two was the better shot. Then they became deadly earnest. Both were good friends of mine, and we hunted together for many years out of a deer camp on ten acres in Underhill, Vermont. Year by year we built, added to, and modified the camp into what was eventually to become a house suitable for year-around living.

When Clyde made the decision to marry, he offered to buy the remaining two-thirds of the camp owned by Angus and myself, with the promise that we would always have a place from which to hunt during the deer season.

Clyde and I agreed on a fair price for my share, but Angus balked at selling. He invented every excuse imaginable for not selling, and every time he did so in my presence, he would wink at me behind his brother's back.

Some time later, we were walking along a muddy logging road above the camp and an unusually impassioned argument resulted regarding who was the better shot - an argument led and instigated by Angus. The road broke out into a meadow that supported a few aged apple trees that had been the orchard for a mountain farm that had long since disappeared.

Suddenly Angus cried vehemently, "I'm sick and tired of this! Let's settle it right here and now! Stand right here!"

As Clyde and I waited by the road, Angus ran to one of the apple trees about a hundred yards away and pinned a folded piece of paper to the trunk of the tree. When he returned, he informed Clyde that he had drawn a circle the size of a dime dead center on the paper and the one who came closest to center would be considered the better shot forever.

Whereupon he lay down in the middle of the mud filled road and shot while lying in the prone position. We all walked to the target to see where the bullet had hit, and there, perfectly centered in the middle of a tiny penciled circle, was a bullet hole.

Clyde didn't say a word as we walked back to the road, but silently lay down in the mud and steadied himself for the same shot his brother had taken. The shot was about one-half inch outside the circle. "Now will you admit that I'm the better shot?" Angus asked smugly.

Clyde nodded sadly in the affirmative.

"That's all I wanted to hear!" Angus said as he clapped Clyde on the shoulder. "By the way, that paper we shot at was the deed for my share of the camp ... it's my wedding gift to you and Helen."

It was almost two years later when Angus swore me to secrecy (that I have held until now) and confessed that he had shot the hole through the deed long before he had pinned it to the tree, and then deliberately missed the muddy road prone shot.

"It's just that much less we have to argue about, and besides, I figured it was a great way to get him down on his belly in the mud." he concluded with a wink.

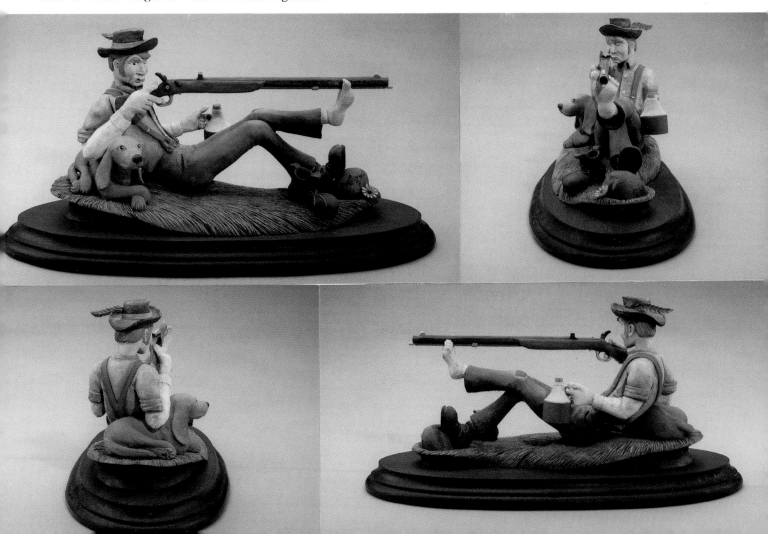

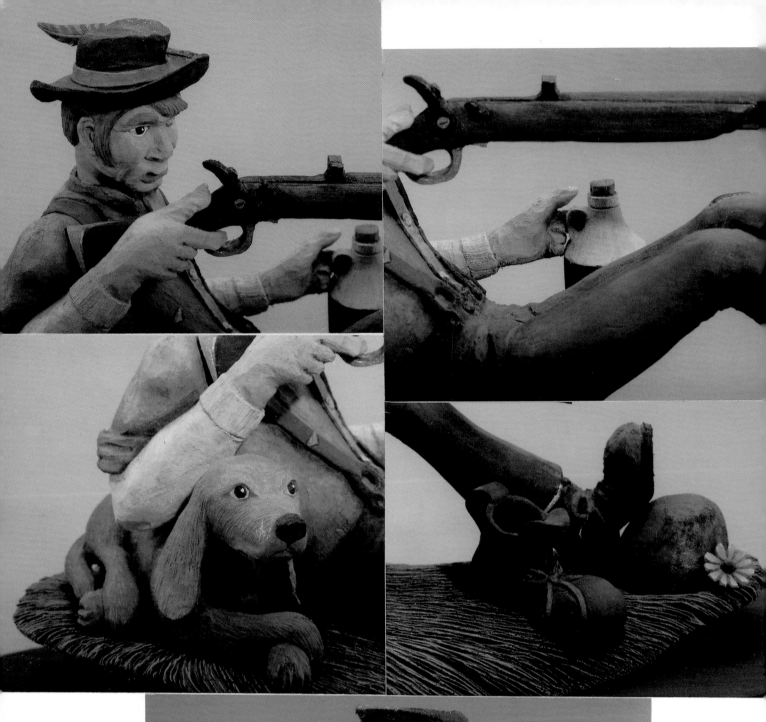

Muddy Road Shoot Off.

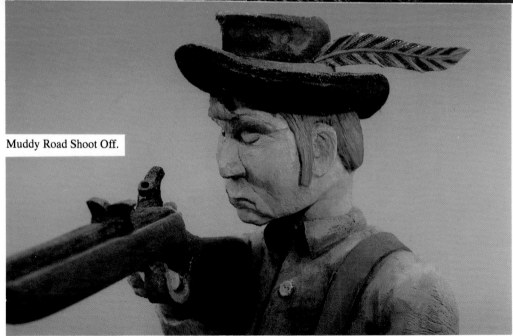